picasso

# picasso

**Hans Jaffé**

759
P586p

12.994

**Hamlyn**
London   New York   Sydney   Toronto

twentieth–century masters
General editors: H. L. Jaffé and A. Busignani

© Copyright in the text Sadea/Sansoni, Florence 1968
© Copyright in the illustrations ADAGP Paris 1968
© Copyright this edition The Hamlyn Publishing Group Limited 1970
London·New York·Sydney·Toronto
Hamlyn House, Feltham, Middlesex, England
ISBN 0 600 36910 2

Colour lithography: Zincotipia Moderna, Florence
Printing and binding: Cox and Wyman Limited
London, Fakenham and Reading

**Distributed in the United States of America by Crown Publishers Inc.**

# contents

## List of colour illustrations

## List of black-and-white illustrations

## A man of our time

Any attempt to find someone whose work and personality completely epitomise our age–and not only in the field of the visual arts–would almost inevitably lead to Pablo Picasso. His work, by reason of its grasp of new problems and its significance in a far wider field than simply that of painting, is one of the major points of reference in this century. As a personality, his courage and boldness place him among those who have given new directions to artistic experience and made an indelible impression on its history.

It may seem almost paradoxical that an art that is so many-sided, capable of so many interpretations, created by a man both obstinate and unpredictable, should have been able to dominate and determine our artistic climate to such an extent. It should be remembered that Picasso's art is a record not only of events and experiences in his own life, but also, and perhaps primarily, those of life generally in the first half of the 20th century. It is then realised that in his art Picasso was able to register historical events as well as changes in the artistic climate of his time or its mood more generally. He could capture, as it were, every beam from every light source, and split them up in the prism of his own personality, so that his contemporaries have each been able, individually, to take advantage of his vision.

Picasso is thus one of the crucial figures of the first half of the century, to be numbered among those who have contributed most to its spiritual, cultural and artistic character. An innovator, he has never allowed his hands to be tied by tradition; he has instead known how to grasp and resolve every new possibility. His competence extends well beyond the limits which might ordinarily be considered to confine his sphere of activity and has enabled him to play a very important role on the broader stage of existence as a whole. Like many of his contemporaries, swiftly joined by those around him, Picasso broadened the horizon of his own and of our times, by abandoning traditional forms and seeking new ones. In this respect he belongs to the ranks of the great, among those flexible intellects that may even be termed Protean.

Although Picasso's work is so new and many-sided, and although it has never been hemmed in by convention or prejudice, his art and his personality are nevertheless deeply rooted in their Spanish origins. The proud solitude which he has always preserved, like the aversion he has always felt towards conformity and convention, is essentially Spanish–the same proud independent spirit of Don Quixote, the same detachment of the Spanish anarchists with whom he had close contact as a young man at the beginning of the century. This independent spirit that is, we must repeat, so typically Spanish, enabled Picasso to give no further thought to his works once they had been finished and had left his studio; for him, by then, they existed in

their own right and he had very few emotional links with them; he himself said 'No painting represents a conclusion, simply a chance event, an endeavour.' In this way there is no line of development in his work but rather a continual renewal and fertile activity which, with all its diversity, even now at the age of over eighty-five, make it possible to think of him as one of our young painters. An essential trait of his personality is his refusal to participate in any preconceived formal pattern. His dictum that 'what counts is originality and invention' seems to be fundamental to the whole of his work, and he has complete confidence in his continually renewed powers of invention. Another statement of Picasso's is 'I do not understand why in painting so much importance is given to the idea of searching.' Because of his ceaseless new invention, his work lacks any degree of continuity that might enable us to view it as if it were a chain whose links lead from one to the other; instead there is such a wealth of innovation and invention that one can only be amazed that it can all have occurred in the life and from the hand of a single individual. The very idea of a chain of works that are mutually interdependent and form a homogeneous whole, is foreign and indeed repugnant to Picasso, who has no desire to remain tied to what he has already completed and who will not tolerate being forced to work in a style that is recognised as 'Picasso's'. The simultaneous presence of disparate styles and irreconcilable meanings in Picasso's work is probably a characteristic trait of the 20th century, a period in which so many different elements of nature, history and art are merged. Picasso was the first to be moved to depict this in his art as in a symphony, which is made up of many sounds quite independent of each other.

That this 'symphony' was meant to be linked with our own age is clear from Picasso's own words–'I have always limited myself to the depiction of our own time.' Others contemporary with him have also observed the century in which we live. But Picasso's impressions have greater impact, recorded straight from his own experience and intuition, through which he was able to record every subtle tremor. It is an age distorted by opposing sentiments, by a continual alternation of hope and fear, whose contrasts and strife Picasso has been able to portray better than anyone else–in a way that preserves its true nature. Truth is thus the eternal aim, and at the same time the origin of Picasso's art. In one of his terser statements he takes the following point of view: 'Art is a lie which enables us to understand the truth'. The quest for truth has always preoccupied him, from the bitterness of his first sketches to his most recent canvases, which, in this connection, are great examples of his constant reappraisal and criticism of the subject and of his own standing as an artist. The truth is sometimes unpleasant and hurtful, but it always stands above the chance event of daily existence which can provide the spark for Picasso's imagination; *Guernica*, which is perhaps his most complete work, is one example among many of this. But the truth that is his constant preoccupation is neither fixed nor inert; it demands involvement. In an interview that dates from the period immediately following the Liberation, Picasso said 'Painting was not invented to decorate houses. It is an offensive weapon in the defence against the enemy'. This enemy is not only any adversary of truth, but also anyone who threatens human dignity and freedom. Precisely on account of this involvement with human beings and their problems, Picasso's work is profoundly linked with our age and with our existence. He holds on to the truth, even if it may at times manifest itself in a form which is ugly and frightening, rather than beautiful. For Picasso, beauty always leads to the conventional, and there are few things from which he has such profound aversion as the conventional and that which conforms. Painting must triumph as the weapon of truth, but 'the academic teaching of beauty is a fraud'. There is no reason for the continuation of a tradition of beauty where it no longer corresponds to contemporary reality. Picasso has indeed dared to place in contrast to this beauty its exact opposite–a diabolical and obsessive ugliness, through which he created a new and tangible form of truth. 'A painter paints in order to

free himself from that which he has become conscious of, from his visions'. One should not interpret this in the sense that the artist wishes to divest himself of those impressions which spurred him towards creation – rather, by giving them material form in his work, he provides a means for others to understand the truth. This, therefore, combined with the fact that he never sought standardised beauty nor set proportions, forms the basis of Picasso's work: many-sided and rich in subtle meaning, not only on account of the period in which it was created (which is characterised by a wealth of antitheses and contrasts, full of colour and at the same time rapidly changing from light to shade) but above all because Picasso as a painter and sculptor, or as a designer of theatre scenery, never felt drawn towards a static ideal or canon of forms. His more than eighty years of life have been lived perhaps more intensely than those of other men and he has found the truth – but in a way that belongs with men of genius, that is to say by chance, through having looked where others could not see. So Picasso, in this century, has enabled us to understand our truth. 'In this age full of grief there is nothing more important than to excite enthusiasm.' These words epitomise Picasso's life and work.

## Childhood years

Pablo Ruiz Picasso was born on the 5th October, 1881, in Malaga in southern Spain, the son of Don José Ruiz Blasco and Maria Picasso Lopez. His father was a teacher of drawing and painting at the local technical school, a man of some talent and good taste, but whose artistic horizons were somewhat limited although he was a good still-life painter. Picasso passed the first ten years of his life in this southern town, where the climate is almost African and history goes back to the most ancient period of Mediterranean culture. A photograph from a family album is the only record that survives from this period. In 1891, when Pablo was ten years old, his father was appointed to a post at the Academy of Fine Arts at La Coruña and the family moved from the far south to this harbour town on the Atlantic coast in the north of Spain. The new surroundings, in which Picasso was to spend a further four years of his life, had a profound effect on the young boy from the south and are continually recalled in representations of the rocky northern coastline which was so different from the beaches of the Mediterranean. It was in these years that Picasso began to paint, under the guidance of his father. A few works which survive from 1893–4 clearly show Picasso as something of an infant prodigy; these drawings explain his father's behaviour. For accounts of this period have it that Don José Ruiz, on seeing his son's work, gave him all his painter's materials and from that time on confined himself to teaching. As an artist he saw very early on that he had found a master in his son.

But wider horizons were opened for the young Picasso when in 1895 his father accepted an appointment at La Lonja Academy in Barcelona, the capital of Catalonia, where the family moved after spending the summer at Malaga. For the first time Picasso stepped outside the closed environment of the Spanish provinces and came into contact with all the new trends, so that he was in no danger of suffocation by the airlessness of a quiet life in the old tradition. In 1896 he was admitted to the drawing classes at the Academy where his father taught, having passed the admission examination with ease, although this presented an almost insuperable difficulty for most of his contemporaries. The knowledge of anatomy and precise observation of detail required were such that only artists of great talent could pass without difficulty. At fifteen Picasso gave proof of this talent (and this achievement is even more notable when one considers that he proved himself to judges of the preceding, conservative generation).

## El Quatre Gats

But everything from the following year shows that he had no intention of allowing himself to be confined by the limitation of academic tradition. He joined a group of young artists and intellectuals who met in the café *El Quatre Gats*. Their ideas were progressive, sometimes revolutionary: in the

field of politics, they were inspired by the aims of socialism and by anarchist ideas; as far as art was concerned they looked to the biting, analytical and critical style of the Parisian avant-garde, artists like Henri de Toulouse-Lautrec, Steinlen and the other illustrators who belonged to that circle, and to the work of English 'decadents' such as Beardsley. From a recent study, by Phoebe Pool and Sir Anthony Blunt, on Picasso's formative years, it appears that the work of the Norwegian Edvard Munch was known to this group, whose interests were directed towards the North. With the *Quatre Gats* group, which included the Gonzáles brothers (the sculptor Julio and his brother, Juan Gris) the critic, Eugenio d'Ors, and the poet, Jaime Sabartès, Picasso gained an awareness of the new cultural trends and visual ideas that were beginning to expand the narrow horizon of Spanish provincial tradition. In this same year, 1897, he held his first exhibition, at the *Quatre Gats* café and for the first time his work was discussed and commented on in an article in *La Vanguardia*. He exhibited a number of portraits of his friends from the bohemian circle of *El Quatre Gats*, and the style of these corresponded to the modern spirit that inspired the group. In this same year the artist also enrolled himself in the Academia Real de San Fernando in Madrid, which was regarded as the fortress of Classicism. Here, too, he passed with ease an examination that selected only the most talented in the whole country. In 1897 he won a medal with a painting entitled *Ciencia e Caridad (Knowledge and Charity)* which shows that his allegorical painting could meet with the approval of the members of a jury whose criteria must have been somewhat traditional. This same ability to create works in the spirit of his conventional and traditional artistic education that were far from ordinary in quality, is attested to by the medals he received at Madrid and Malaga for the painting *Costumbres de Aragon*—not mean achievements for a young man of hardly seventeen. The conservatism and traditionality of the academic style must certainly have irritated the young Picasso. In 1898 he left the Academia de San Fernando, despite the fact that all the doors to a 'traditional' career were now open to him. He spent a large part of his time in the country, convalescing from an attack of scarlet fever, and nothing precise is known of his work at this time, but Picasso must have made considerable progress towards a more advanced style. In 1900 the review *Joventud in Barcelona*—which corresponded to the *Munchener Jugend*—published some of his drawings, which were clearly derived from *Art Nouveau* or *Jugendstil* forms.

Under the influence of this new enthusiasm, he undertook a journey to Paris with his friend, Carlos Casagemas, who was also a painter. Paris was the centre of the new movement, and any young artist who was caught up in it would have wanted to meet its key artists or at least see their works in the proper environment. With his visit to Paris, Picasso was following the example of many other artists of his generation who congregated from all parts of the world in this, the capital of the arts. The trip could in some ways be termed a success; he sold some of his drawings to Berthe Weill, the most avant-garde of the art-dealers, and he also acclimatised himself, so to speak, to Parisian life. Little is known of the character of his paintings during this first stay in Paris, although we can assume that some pastels exhibited the following year at the Salon Pares in Barcelona were the result of his work in 1900. The choice of the pastel medium is certainly an indication of the in-

Pls. 1, 2   fluence of Toulouse-Lautrec, which is evident without a shadow of a doubt in the following year, when Picasso made his second visit to Paris and his pastels and oil-sketches all have subjects from the cabaret bars.

**Arte Joven**   But the year 1901, which was Picasso's twentieth, brought a total change in him. Already in the spring he had, together with his friend, F. Soler, begun the publication of the *Arte Joven* review that was intended to bring some of the satirical and critical tone of liberal Barcelona to the capital. The character of this review was biting; it was devoted to social criticism and was clearly hostile to the bourgeoisie, and this was the nature of the illustrations that

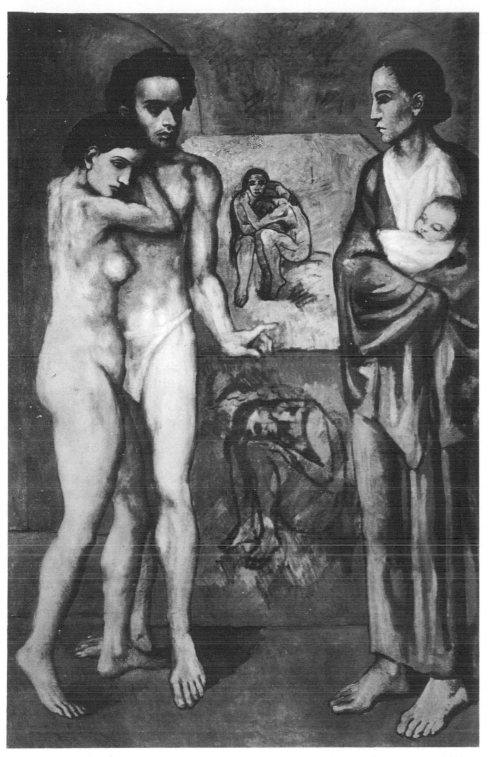

1. *La Vie*
1903, oil on canvas
$77\frac{1}{2} \times 50\frac{1}{8}$ in (197 × 127·3 cm)
Museum of Art, Cleveland

Picasso drew for the first issue. After the second number the review had to cease publication. When the first appeared, Picasso set out for Paris again. Here he met a fellow-countryman, P. Manach, who offered him a contract and lodging in his apartment on the Boulevard Clichy, in the quarter of Paris where Picasso was to live and work during most of his early years there. In the same year he received special recognition from Ambroise Vollard, the art-dealer who was always in touch with the latest developments in painting. He organised an exhibition of Picasso's works that was reviewed most favourably in the *Revue Blanche*. Another exhibition in Barcelona was also discussed enthusiastically in the *Pel y Ploma* review. All the works that were exhibited, both in Paris and in Barcelona, stemmed from the influence of Toulouse-Lautrec. Line assumes a new importance in arabesque forms and bold and strident colours are distributed in wide areas, giving the canvases an impression of nervous dissonance. An unmistakable originality underlies these works, but it is impossible so far to say that Picasso had reached a true personal style. This he achieved in the autumn of 1901, when he was barely twenty. A few works here and there, such as *Girl with*

*Pigeon*, already point with their more restrained manner and more intense quality on more personal themes, to a new phase. Picasso himself was conscious of this change in his style and of having turned his back on a style that was already accepted and well-received; he was now leaving behind the effect he could so easily achieve with his flexible talent that had so early on demonstrated its virtuosity, in favour of a new and personal view of life and the world. From now onwards, from the end of 1901, that is, from the beginning of the Blue Period, Picasso no longer signs his paintings in full—Pablo Ruiz y Picasso—but with his mother's surname—Picasso.

## The Blue Period

Pls. 3, 4
Fig. 1

What are the characteristics, what is the meaning of this new style for which his biographers have chosen this all-too simple term 'Blue Period'? Indeed, the canvases which date from the period which extends from the end of 1901 up until the end of 1904, painted both in Barcelona and Paris, are, in fact, characterised by the colour blue—a cold and rarefied blue. But this blue is not only a colour, it creates an atmosphere that is in keeping with the subjects, with the human character of these paintings which represent the outcasts of society—blind beggars, itinerant musicians, tramps—those who spend their lives in wretched poverty or humble servitude. Picasso paints such characters, a guitar player or an old Jew, with the sympathy and condolence of a man who himself belongs to the fringe of society. And in order to express their feeling of solitude, abandonment and misery, in order to evoke a world without comfort and without hope, he chose the highest order of symbolism—the sullen and severe blue of an early winter's morning. The figures stand in front of and are immersed in this blue, a cold infinity, in a world with which they can never have contact—behind them and around them there is nothing but void. The choice of colour is therefore not arbitrary, nor is its limitation to a single tone simply an aesthetic device; the Blue Period is the artist's expression of the human condition seen vis-à-vis his fellow human beings and society, which is surprisingly in tune with that feeling of melancholy despair and utter sadness which is the dominant note of Rilke's poetry during these years. This *'mal de siècle'* involved artists of the profoundest feeling, and their shared emotion may be seen as proof of its authenticity. Picasso spent only part of the Blue Period years 1901–4 in Paris; the majority of this time was spent in Barcelona. At every opportunity he exhibited in Paris, either at Berthe Weill's or at Vollard's, and during subsequent visits he became friendly with the poet Max Jacob, the critic Gustave Coquiot and other personalities of the artistic and intellectual world.

In spite of this, up till 1904 Barcelona remained his true place of residence and this fact seems to me to explain some of the characteristics of his work which are still connected with Spanish tradition, although not the Spanish tradition officially recognised. The affinity of his harsh and elongated figures with those in paintings by El Greco, their ascetic appearance and introverted character, cannot be regarded as entirely fortuitous. A closer link can be seen in one of the Blue Period paintings: *The Funeral of Casagemas*, painted after the tragic suicide of his friend and travelling companion, almost right at the beginning of the Blue Paintings. This painting is divided into two parts—the terrestrial and the heavenly—as in El Greco's *Burial of Count Orgaz*. This analogy with El Greco seems to be typical of Picasso's creative process: he is continually searching—and, in this instance, for the first time—for points of contact between essential phases in his own art and parallel phenomena that he sought to isolate in the art of the past.

## The Pink Period

The end of the Blue Period, which is marked by this ascetic, introverted attitude towards humanity and by Picasso's sympathy with the rejects of society, coincides with the artist's decision to take up permanent residence in Paris. In 1904 he left Barcelona and set himself up in the Bâteau-Lavoir, that strange building at what used to be 13, rue Ravignan, which was used by several artists as a studio and for living in, and where, among others,

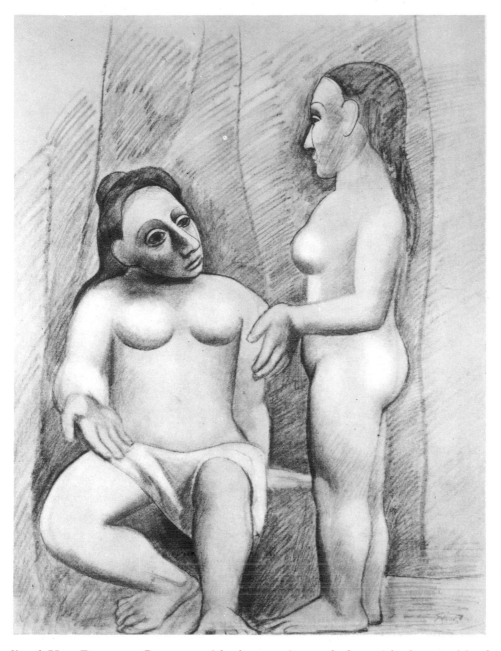

2. *Seated Woman with a Standing Woman*
1906, charcoal
24⅛ × 18¼ in (61·2 × 46·4 cm)
Museum of Art, Philadelphia

lived Van Dongen. Contact with these artists and also with the world of the Medrano Circus nearby, the feeling that he was completely accepted within a group, led to a change of attitude towards humanity and at the same time to a change in Picasso's style. Once again it is a colour which provides the outward expression of his inner feeling, symbolises and represents the synthesis of it: appropriately this new phase in Picasso's art is called the 'Pink Period'. A soft pinkish terracotta, mixed occasionally with pale ochre, is the dominant note in the new range of colours which express a tender intimacy and an engaging warmth. The colour itself is perhaps the clearest indication of his changed attitude towards life, but the figures themselves, their poses and the way in which they are arranged are also expressive of it. There is an immediately apparent interplay of gestures and complex relationships among the figures—as the glance of one seems to catch another's —instead of being lost in nothingness as in the Blue Period. At the same time another thing will be noticed—the figures are given a dimension in their world. Although this is barely suggested, it is very different from the cold immeasurable void that accompanies the sadness of the figures in the Blue Period. The warmth of Picasso's new palette went hand in hand with the new warmth he felt towards the world.

In this new style, provoked especially by a feeling for life, problems of form rapidly assume importance and become the artist's main preoccupation. Mass and volume play an ever-increasing role. The forms in his painting derive increasingly from those of sculpture, and if we adopt the expedient

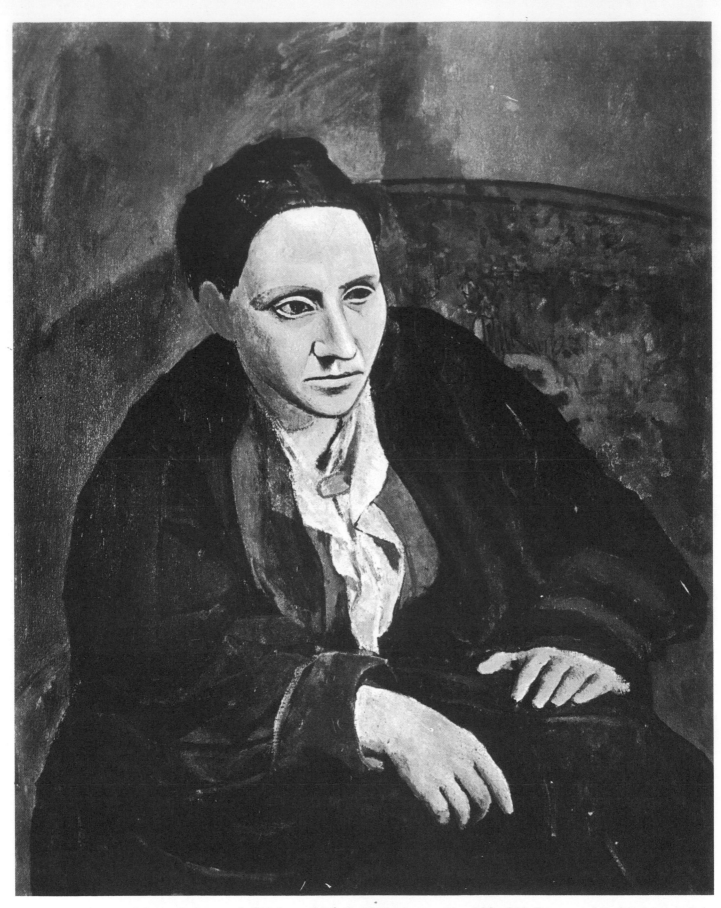

3. *Portrait of Gertrude Stein*
1906, oil on canvas
$39\frac{3}{8} \times 31\frac{7}{8}$ in (100 × 81 cm)
Metropolitan Museum of Art,
New York

definition which the American critic, Alfred H. Barr, used in this connection, we can say that the Pink Period is followed by a Classical Period, during which Picasso was inspired above all by the Greek sculpture he could see in the Louvre. *Boy leading a Horse* is an example of this style; the body of the boy is remarkably similar to one of the early Greek *kouroi* in the Louvre. This tendency is foreshadowed in one of the paintings of the Pink Period, in the marvellous *Girl with a Ball* in the Hermitage, Leningrad. The way in which the dark body of the athlete seated upon a cube contrasts with the lightness of the girl balanced on a ball reveals the artist's interest for mass

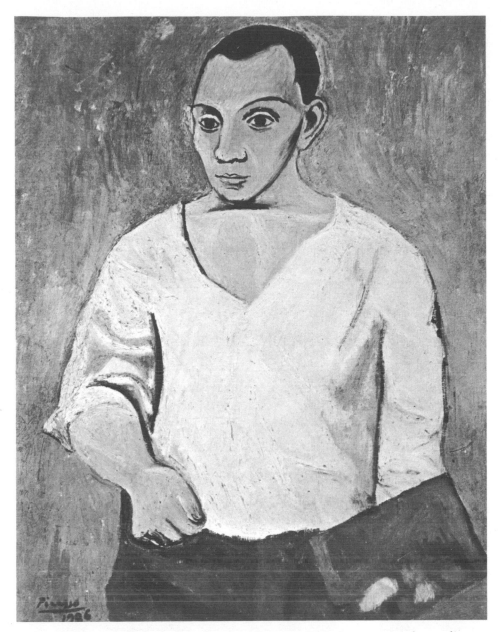

4. *Self-portrait*
1906, oil on canvas
$36\frac{1}{4} \times 28\frac{3}{4}$ in ($92 \times 73$ cm)
Museum of Art, Philadelphia

and volume and their symbolic significance. This interest in three-dimensional form, entirely in the round, could be connected with the journey Picasso undertook in 1905 to Holland on the invitation of the journalist Tom Schilperoort; we know from other evidence, apart from the individual paintings of this period, that Picasso was keen on the fulsome forms of Dutch women. His first sculptures also date from this period, including notably his *Head of a Woman*, where the softness of the forms and the sharply accentuated roundness present obvious analogies with the paintings of the same period. Picasso thus devoted himself at this stage, following his preoccupation with humanity of the Blue and Pink Periods, to resolving new problems of form.

Pl. 5

The transition from one stage to the next is clearly apparent in a comparison of *Woman at her Toilet* in the Museum in Buffalo, and *Hairdressing* in the Metropolitan Museum, New York, which was painted only a short time later. In the first painting the subject revolves around the psychological antithesis of the two figures; in the other it is a pyramid of forms, a construction in space. This transition anticipates the manner that became characteristic of Picasso's work in 1906 and 1907, which in turn constituted a material step towards the revolutionary change which came about in 1907.

At the same time Picasso's way of life underwent a marked change. He came to know Guillaume Apollinaire, to whom all avant-garde artists looked for advice, he met Matisse and began a long friendship that was to end only with the death of the Fauve leader, and found his first patrons in the American brother and sister, Leo and Gertrude Stein, who were soon

joined by the Russian collector Shchukine. He spent these years of struggle and artistic innovation living with a new-found friend, Fernande Olivier.

Fig. 3 We have a clear understanding of the change that had come over Picasso's work during the summer of 1906 in the portrait of Gertrude Stein that was painted in the same year. The likeness is rendered with an accumulation of shaded brushstrokes in calm and restrained colours strongly reminiscent of the Pink Period style, although there is more emphasis on form than on the feelings evoked by the colours. The hands and face make a special impact in this somewhat 'closed' representation; the face is mask-like and motionless, with a strong contrast between the wide flat area and the almond-shaped eyes, the small mouth and the nose which is given a sculptural plasticity. The ambiguous character of this portrait has a simple explanation: Picasso began it during the first part of the summer of that year and had made considerable progress with it after numerous sittings, but he was not satisfied with the face. Before he finished it, he set out with his friend Fernande Olivier to spend the summer at Gosol in the southern Pyrenees. Here he examined the problem of plasticity in simple and isolated forms in a series of studies and sketches.

It is possible that this increased interest in plasticity was provoked by an exhibition of Iberian sculpture that Picasso had been able to see in the same year at an exhibition at the Louvre. These make a strong impact on the eye precisely on account of their bold simplification. It is quite characteristic of Picasso's creative process–as we have seen in the Blue Period–for him to give special emphasis to a single aspect of his art by looking to the past. In any event, on return from his holiday, he returned to the Stein portrait and painted the face without having her sit for him again. The result is a mask-like appearance that is nevertheless enhanced by a strong suggestion of depth and by the very solid hands. It is self-evident that this work leads the way to a new style that is no longer involved with psychological subtleties nor even with the expression of a state of mind, but rather with presenting the force of reality through the suggestion of depth.

Fig. 4 Picasso followed through the line of development made possible by the *Portrait of Gertrude Stein*. His *Self-portrait* of 1906, in Philadelphia is closely linked with the second phase of the picture of the American authoress. There are the same almond-shaped eyes, that same appearance of mass, not achieved through modelling in light and shade, but through the emphasis given by large areas of colour. It is immediately apparent in this work, carried out when Picasso was twenty-five, that the artist was not seeking a psychological rendering of himself but was in fact using the features of his own face merely as the starting point of a sculptural composition.

The next stage, represented by another *Self-portrait* in the Museum in Prague, is characterised by the same sort of freedom. The face, which still has the same large almond-shaped eyes as its focal point, is not drawn with curves and wide oblique areas as before, but seems instead to have been cut with a scalpel and to be composed of distinct areas that are harshly separated from each other. Even more than the one of the preceding year, this painting foreshadows the great revolutionary work, *Les Demoiselles d'Avignon,* that was to entail a change of direction by no means limited to Picasso's own art. But this painting should be considered in connection with the most significant artistic event of 1907–the commemorative exhibition of Cézanne's work. For a whole generation of young artists, this was the first opportunity of fully comprehending the work of this great master of architectonic composition, whose profound inner feeling for order led him beyond the innovations of Impressionism.

## Les Demoiselles d'Avignon

The remarkable retrospective exhibition of Cézanne's work, that was to have an influence unequalled by any other on the painting of this century, opened in the autumn of 1907, when Picasso had almost finished the painting that was to open the way towards a completely new style. In this work all the traditional attributes of beauty have been thrown to the winds and it is

Pl. 6

only the forceful forms that compel the spectator with their magic power. All detail and anecdotal literary allusions have been shed in the course of the long hard work which went into its creation. At first the painting was to have the allegory of Vanity as its theme; in the middle of the first sketches there is a sailor surrounded by a number of nude figures which, as in some of Cézanne's later works, form an architectonic composition of bodies. All these extraneous associations were progressively discarded in the course of a series of studies and one can see how the painting itself was the product of a number of successive phases. The figures in the middle are clearly related to works like the *Portrait of Gertrude Stein* or the 1906 *Self-portrait*; the shape of the faces, the almond-shaped eyes and the toned-down colours are some of the links with these works. The canvas was worked on almost as if it was a triptych – the part on the left contains a figure resolved in broad areas much as a boldly hewn-out piece of wooden sculpture; the style here has great affinity with the *Self-portrait* of 1907. On the right-hand side, with the crouching figure and one on foot, Picasso has gone even further – what remained of a naturalistic representation is abandoned and a magical form created that is more the symbol of a nude figure than its actual image. This is the crucial step from the concept of an art that is dependent on imitation of the outward form of nature, to an interpretation of reality in an independent pictorial language. This language involves the realisation not only of the anatomical forms of the figures, but also of the space around them (which seems to have been carved out in much the same way as the figures themselves), and also the tent which confines the composition on the left; all reality is one and is treated according to the same laws.

All in all, with its reduction of the subject to its constituent formal elements this canvas may be said to be the true starting-point of Cubism.

Here again Picasso displays his way of approaching problems in painting – his art became more meaningful with the direction he had taken towards solid, sculptural forms with a whole series of new ideas. It is possible that African art, at that time the most recent discovery of French and German artists, directed him towards a magical intensity and elementary forms.

The work of Cézanne, which in 1907 had made such a forceful impression on a whole generation, was to assist Picasso through the various stages in the development of a new language of forms.

1907 was also the year of another milestone in the progress towards Cubism, for it was in that year that Picasso met Daniel Henry Kahnweiler, a young art dealer who had recently opened a gallery. In Kahnweiler Picasso had found not only a lifelong friend, but also a convinced and perspicacious supporter of the new artistic trend to which, by reason of his knowledge of philosophy, he was able to make a valuable contribution as the explainer of its aesthetic foundation. Picasso's circle expanded further with the friendship of painters of his generation such as Georges Braque and André Derain, who were to play essential roles in the development of Cubism.

The following years were devoted entirely to the evolution of this new pictorial language. In 1908, the year when the word 'Cubism' was first employed in connection with an exhibition of some landscapes by Braque at Kahnweiler's gallery, the influence of Cézanne was dominant, particularly the latter's teaching regarding the reduction of the forms of nature to simple geometric shapes. The imposing representations of women (such as *Woman with Fan* or *The Great Dryad*) which seem to belong to an almost superhuman race, involve an even clearer reduction to elementary forms than the landscapes Picasso painted in the rue des Bois in Paris. These brought green back into Picasso's paintings again – a saturated green that makes a happy combination with the red-ochre and grey.

But this search for a new formal structure involving an analysis of shapes and things is clearest in the series of still-lifes: which had been the medium of some of Cézanne's most advanced experiments in his pursuit of pictorial composition. The contrast that exists between elementary forms is the theme of Picasso's arguments.

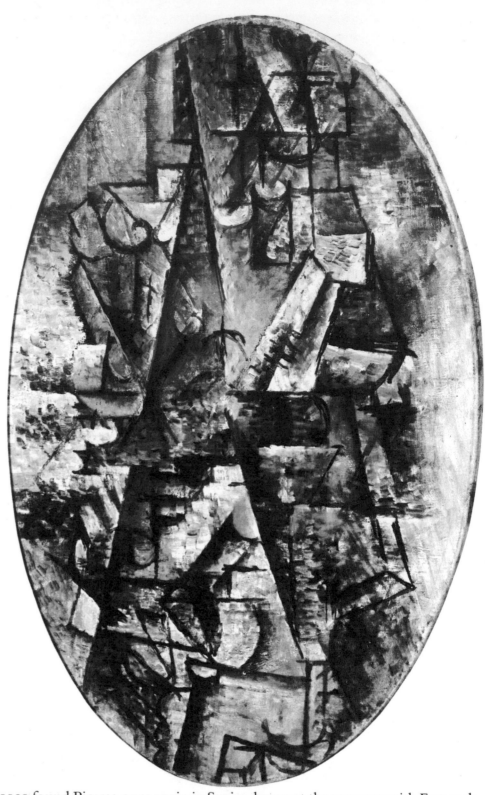

5. *Man with a Mandolin*
1911, oil on canvas
Mattioli Collection, Milan

**Analytical Cubism**   1909 found Picasso once again in Spain—he spent the summer with Fernande Olivier at Horte de Ebro, the same village where in 1898 he had recovered from his illness. The hard and angular forms of this village and the surrounding landscape under a blinding sun provided the inspiration for the first landscape with a true Cubist structure. The village, the hill and the air above and around them are reconstructed in blocks, in geometrical shapes; the painting attempts to show a chance segment of nature as an organised whole, as a 'composition'. The ideal form of this period seems to be that of a crystal

Pl. 9   —one which by natural law has a sharply defined pattern. But this structure is found in other paintings besides landscapes; the small *Head of a Woman* of the same period demonstrates that Picasso's forms are not merely associated with a handful of objects, but extend to the whole of reality. This little masterpiece is built up of small areas, of facets of ochre, grey and brown which share a pattern between them like the facets of a gemstone.

While Picasso bases himself on Cézanne, he goes beyond him; on a single

18

level he throws a number of different subjects into separate relief, just as a chemical process might isolate the more complex elements from a series. Not without reason, therefore, is this phase of Cubism—exemplified by his *Head of a Woman* of 1909— known as 'Analytical Cubism'. Formal analysis, the dissection of a form into its constituent elements, is extended by Picasso in that year beyond painting—and this gives some idea of its scope—into three dimensions. A *Head of a Woman* in bronze of 1909 shows the same tendency to formal analysis, the same reduction of his subject to elementary forms, and is closely linked with paintings of the period. It is built up of small flat areas set against and contrasted with each other, giving the impression of a faceted surface symbolising a woman. This analogy that exists between the media of painting and sculpture shows that this is no aesthetic game, rather a search for new forms with which to interpret the world because the conventional and traditional ones no longer prove satisfactory. The artist is thus looking for a figurative language that no longer represents the appearance of reality, but rather the essential order that lies behind it, the pattern according to which forms come into being.

This Analytical Cubism reached its first heights in a series of portraits that Picasso painted of a number of his friends in 1910. *Girl with a Mandolin* (a portrait of Fanny Tellier) begins the series, which ends with three portraits, those of the art critic Wilhelm Uhde, the art dealer Vollard and Picasso's friend Kahnweiler.

Pl. 10

In these paintings a rigid system and a precisely structured figurative language are applied to individual objects, and indeed to three different persons, each of whom are shown in an individual manner without the artist having to make the slightest sacrifice in his method of painting. The image of the person is constructed in a different way each time, with facets and superimposed planes that certainly do not represent space in the traditional manner, but give a strong impression of depth. It is not as if the figures are placed inside this space—rather it is their formal arrangement and the way in which they are constructed that produces a sense of space which, as had already been the case in *Les Demoiselles d'Avignon*, includes the objects and their surroundings. A few details, such as the wider border of the portrait of Uhde and the watch chain in Kahnweiler's folded hands, endow the characterisation with a rhythmic element and show how Picasso consistently employs a 'rhyming technique' with which he brings out the similarities in different forms in their different contexts.

By 1910 Picasso had achieved such mastery of the language of Analytical Cubism that he could use it to lyrical and poetical ends. Certainly this poetry, which reaches a different stage in the still-lifes of 1911, is a sober and disciplined affair, following strict principles and perhaps not even immediately apparent. So these works of 1911 are extremely restrained, with very sober colouring and the compositional structure worked out to the last detail. Usually their subject is taken from everyday objects—such as a still-life with glasses and bottles on the table of a café or a musical instrument with some lines of music on a chair. What is enhanced is the nobility of everyday objects, the poetry of the mandolin or of the violin; these qualities do not stem from the images of the objects themselves, but principally through a new figurative language—the objects build up their own life in a world with its own meaning.

Pl. 11
Fig. 5

From these same years date the oval paintings, which demonstrate even more the new achievements and independence of the picture. The oval format has a special significance in the context of the aims of the new figurative language. In the first place it has no starting-point—a fact that makes it difficult to convey the impression that the objects have any reference to space outside the canvas. They are on the surface of the canvas and are set in space but space which they must create for themselves—and it is this idea of space that preoccupies the artist. Further, the oval shape gives weight to those forms that are concentrated about the centre: an oval always appears to draw itself in towards its two axial points. The second reason why

Picasso, and following his lead the other Cubists, chose this shape is because it is self-enclosed and because of this the objects exist in their own world and bear no relation with all that is visible around the painting. The objects themselves are given a new independence, for they are no longer seen from the point of view of the observer; consequently their appearance owes more and more to the objective construction of the painting. For this reason an object is no longer seen from one side only, but from front and behind, above and below, and its most characteristic features are synthetised in a configuration that places emphasis on a suggestion of its depth. So, in liberating itself from subjective considerations, painting also evidences a tendency towards democratisation. Another dimension is discovered at the same time – a fact that was very important for all fields of thought at the time – for in the representation of a single object from different view-points, the artist is taking the time-factor into consideration, which is what we now know as the fourth dimension. This fact, too, contributed to the autonomy of the representation and to the isolation of the depicted objects from the outside world and any accidental elements in it; through the new figurative language, it also brought meaning to the independent reality within the painting.

This already complete figurative language, which Picasso had fully mastered in 1911 in the series of oval canvases, was further enriched in 1912 in a number of compositions which mainly have figures as their subjects. While the still-life had served him as the medium for making himself conversant with the new language, it was in figure-painting that Picasso was to take it to its heights. In these paintings, of which *Aficionado* is perhaps the most fascinating, representation is simplified further; the small facet-like brushstrokes are replaced by broad areas vigorously painted, set against a framework of vertical and horizontal lines. Within this almost abstract pattern, the characteristic details of the objects are refined upon; Picasso attached too much importance to reality to break away from it completely. What is most interesting about these paintings is the way in which reality is made totally objective – its representation is shown in such a way that it depends on the principles of the figurative language and not on the subjective approximation of the artist's vision. This has come about in the large compositions of 1912; the patterning of the forms, the limited colour range and the spatial arrangement are all part of this objective approach, the brushstrokes alone remaining as evidence of the subjective element in this process of creation.

## Synthetic Cubism

At the end of this year and at the beginning of 1913, Picasso together with Braque, with whom he had worked assiduously during the preceding years, found the solution to this final problem (and it was inevitable that it should have become a problem for these painters) in an innovation that was to be of great significance for Cubism – collage. This technique had two implications: on the one hand it brought elements from actual reality into the otherwise closed unit of the Cubist composition, breaking what had become almost a code language, while in the other it now made objective the only part which had remained subjective in a Cubist painting – the brushstrokes are replaced by an appropriately objective way of applying colours. Here one of the most rigid principles that can be attached to production in our century finds an application in the field of painting: the artist becomes aware, just like the engineer, the architect or the builder, that he can avoid fashioning the actual constituent elements of the finished work and that he can instead incorporate ready-made elements from other sources. In this way Picasso in one of the earliest collages – if it is not even the very first – employs a piece of waxed paper printed with a pattern of caning in order to indicate a chair seat. From ideas of this sort he developed a system of forms in which the 'real', the 'imitation' and the 'artificial' take part in continual interchange and permutation. What remains of the original Cubist compositions are the principles of the distribution and arrangement of the forms: the piece of paper, on which other pieces of coloured paper might be stuck,

plays no less an active role than the areas of other colours or different shapes that might be arranged in the same composition. This process gave rise to a number of still-lifes of great purity and poetic meaning, just as sheets on which music is not only the subject, but also the poetical content and the rhythm.

Pls. 12, 13

Collage, was one of the factors that enabled Cubism to progress to its next phase – that known as 'Synthetic Cubism'. It was no longer a question of the analysis of forms in nature and their dissection into their several parts; their constituent elements and the way to juxtapose different objects had already been discovered and there was no point in repeating the same experiments. Just as in science, analysis was followed by synthesis. With the principles that had been arrived at, artists could now move towards the creation of new things which had no basis in reality but which were conceived artificially.

The clearest description of this transformation is in the words of Juan Gris – who contributed materially to the development of Cubism in precisely these years – when he explains that while Cézanne and with him the first Cubists sought to render a bottle in the form of a cylinder, he (and this applies also to the work of Picasso at the same period) started from a cylinder in order to create a bottle, and what was more, a much more accurate one. The change that is anticipated in the 1912 figure paintings and the collages, is fully carried out in the still-lifes and above all in the great figure compositions of 1913. *Woman in an Armchair* is a monumental example of the new way of seeing, full of harsh intransigence. In 1914, both the figure-paintings and the still-lifes show how Picasso was able to translate the experience he had gained from collages into the medium of oil paint. They clearly represent an advance in the distribution of forms and the overall framework is much richer. Just as the pieces of paper in the collages were contrasted with the ground both by colour and by their textural differences – rough against

Pl. 14

Pl. 15

6. *Reclining Bather*
1920, pencil
18¼ × 24⅜ in (46 × 62 cm)
Marie Cuttoli Collection, Paris

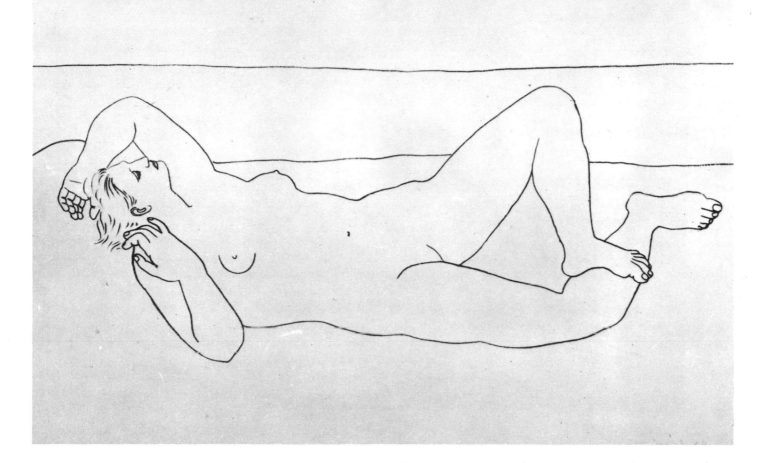

smooth, polished against matt – so, too, in his oil-paintings Picasso exploits the difference between different surface qualities. To the compositional measures of form and colour he adds a third, which may perhaps be most satisfactorily described by the musical term 'timbre'. Just as the composer can enrich his score by having a tune or rhythmical sequence played by the strings, woodwind, brass or percussion, so Picasso endows his compositions with variety – as in *Girl with a Fur* or the still-life *Vive la France* – by enhancing colours and surfaces with different textural qualities. Roughness is achieved by the addition of sand, a polished surface by using lacquer colour, and a matt effect by using tempera paint. Picasso's intention is that the painting should be an increasingly self-contained world which owes its effectiveness to its own language, rhythm, subtle interplay or suggestion of magic, and that this world should ultimately be considered on the same level as reality itself, so that it should be capable of interpretation. This phase of Cubism, as Kahnweiler accurately observed, is a *'peinture conceptionelle'* in which the real point is to give form to concepts, not to the imitation of ordinary objects. The works which Picasso painted late in 1914, which have been described as 'Rococo Cubism' on account of their lightness and brilliance, do indeed demonstrate how much the spiritual meaning predominated over any idea of visual virtuosity. This is a new way of seeing the world, no longer based on the outstanding gifts of a single individual but rather on the fact that the reality that surrounds us is governed by certain essential laws, which are represented by the ordered composition of these paintings.

But the Cubist movement, which had begun in 1907 with *Les Demoiselles d'Avignon* and had been led by Picasso together with Georges Braque and Juan Gris, came to a premature end with the start of World War I. Cubism had developed through the collaboration of a closely knit group of artists against a background of widely differing interests. The majority of these painters who had contributed to the creation of the new style were called up into the armed forces; only the two Spaniards, Picasso and Juan Gris, were able to carry on with their work.

**Co-existence of different styles**
Fig. 8

Picasso's development too shows a break in continuity at this point. While he continued to produce masterpieces in the Cubism idiom, and while the two versions of *The Three Musicians* of 1921 may be regarded as the highest point of the Synthetic phase, Cubism no longer remains Picasso's only style nor the only vehicle for the expression of his concept of reality. In 1915, to the great astonishment of his friends and collectors of his work, he produced the portrait drawings of his friends Max Jacob and Ambroise Vollard, which are entirely in the great tradition of Ingres and Degas. In 1916 there is a further Cubist masterpiece in *The Guitar Player*, but in 1917 he seems to combine the two expressive languages which he had at his disposal. He travelled to Rome at the invitation of Jean Cocteau to design the set and costumes for the latter's ballet *Parade*. He set to work feeling completely unrestricted – the show was played in a joyous, almost realistic manner even though the costumes of the principal characters – the famous overlords – were designed on Cubist principles. Their broad geometrical patterns made a strong contrast with the costumes of the other figures, a contrast that was intended to emphasise the difference between ordinary beings who had grown according to the rules of nature, and those who dominated them.

So what is the meaning of the co-existence of different styles in the work of one artist? It seems for the most part that Picasso was anxious not to make a final choice, that freedom of expression was of the utmost importance using whatever form was currently the most apposite. This should be read as meaning that he did not wish to be tied to a system or language of art, even though its grammar and structure was the product of his own creation. Perhaps also the fact that he spent part of 1917 in Spain lent fuel to his fierce independence, that is certainly to be connected with Spanish anarchism and the feeling for freedom that he had encountered in his youth among his Bohemian friends in Catalonia. In 1917 the presence of these different styles

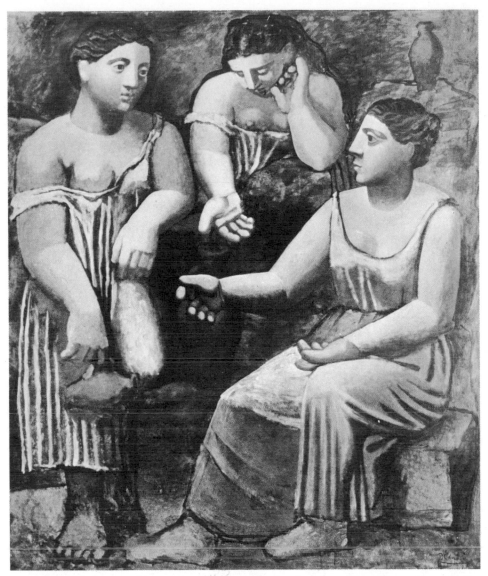

7. *Three Women by a Fountain*
1921, oil on canvas
$80\frac{1}{4} \times 68\frac{1}{2}$ in ($204 \times 174$ cm)
Museum of Modern Art, New York

assumed still greater importance, not only in the portrait of Igor Stravinsky (whom he met in Rome while working with Cocteau), where the harshness of his line conveys a monumental effect, but also in other paintings in which he adopted this same accurate and yet almost stenographic manner of describing natural forms. Such a work is *Portrait of Olga Koklova*—the ballerina from Diaghilev's Russian Ballet whom Picasso was to marry in the following year—which is painted in the same style as the portrait drawings. It is a faithful likeness with great attention to detail, but overall the representation becomes disassociated from reality by reason of the fact that the various details are shown on the canvas as if they were the pieces of paper of a collage.

In the same year as this portrait, which is outstanding in Picasso's work, he painted *The Italian Woman*, a work which returns to the Cubist idiom and is comparable to the brilliant compositions of 1914. Picasso's stay in Rome and his collaboration with Cocteau and with Diaghilev's ballet company, had two immediate consequences for him. He discovered the art of antiquity and that of the Italian Renaissance and he became aware of Roman sculpture, the severity of classical architecture and the monumentality of the ancient ruins. But above all he came into contact with the world of the *Commedia dell' Arte*, filled with the now gay, now melancholy personalities of Pierrot and Harlequin, Colombine and Grazidlas.

Full rein is given in 1918 to his sympathy for this sort of subject, in paintings such as *Seated Pierrot* in the Metropolitan Museum, New York, and with it comes a new range of colours inspired by the stage lit by coloured reflectors.

During the following years, especially after 1920, classical references and subject-matter also make their appearance. This development is most apparent in 1921, a year in which two masterpieces representing entirely

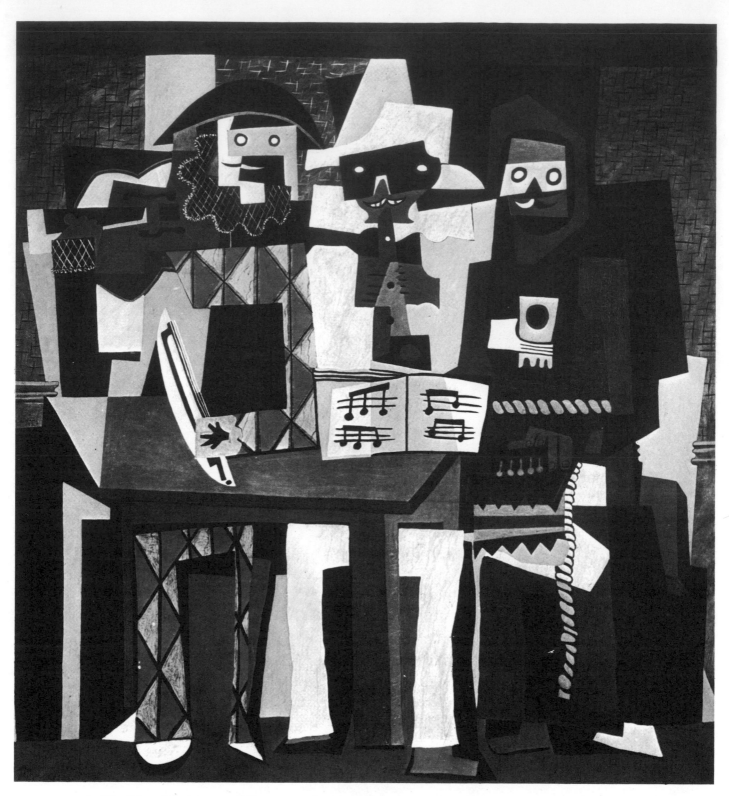

8. *The Three Musicians*
1921, oil on canvas
79⅞ × 74 in (203 × 188 cm)
Museum of Art, Philadelphia

Fig. 7

Fig. 8

different tendencies were created within a short space of time during a stay at Fontainebleau. These were on the one hand the two versions of *The Three Musicians*, which represent the high-point of Picasso's Synthetic Cubism, and on the other *Three Women by a Fountain* which is his first masterpiece in his neo-classical style. The two versions of *The Three Musicians* (of which the one in New York is the most compact and successful) takes the spectator into the world of the *Commedia dell' Arte*; three figures, Pierrot, Harlequin and a monk, are each playing a musical instrument (they are in a different order in each version). So far as their arrangement is concerned, we can see that Picasso has taken advantage of his experience in the field of collage—the brightly patterned areas formed by the clothes of the figures might equally well come from an assortment of pieces of coloured paper. It is particularly remarkable (and this is most evident in the hands) how the figures are conceived of as symbols, just like those on playing cards or badges. In sharp contrast, the forms of the *Three Women by a Fountain* are altogether sculp-

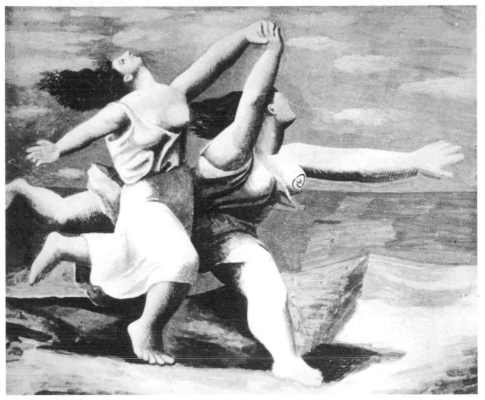

9. *Two Women Running on a Beach*
1922, tempera on panel
12¾ × 16¾ in (32·5 × 42·5 cm)
Sketch for the backdrop of
Cocteau's *Le Train bleu*

tural in handling; these three huge forms seem to belong to a race of giants and yet they are striking for the compact and self-contained quality of their volume. The folds of their robes give the figures the appearance of fluted columns and their whiteness contrasting with the flesh-pink and Siena red of the background, looks like marble and further emphasises the solidity of the forms.

**Feeling of a Classical idyll**

In this painting and in the whole series connected with it a sculptural feeling and a mass predominate, recalling works from 1906, the period of the portrait of Gertrude Stein. This emphasises the fact that throughout his career, Picasso, who never ceases to astound by the lack of continuity in his development, will go back to certain moments from earlier works and incorporate characteristic elements from them in his newest creations. But above all a vital new sentiment makes itself felt in this neo-classical phase; after the first World War, the rebirth of the Classical world was widely participated in not only by painters and sculptors but also by writers and poets. The chaos and fear of the war years are followed throughout Europe by a sense of relief, which often appears in classical garb: '*Et in Arcadia Ego*' often seems to be the motto of this new view of life.

Another element must have contributed to Picasso's dream of a classical world: in 1920 Olga Koklova whom he had married in 1918 had borne him a son, Paul. Immediately afterwards, in 1921, the theme of maternity makes its appearance in his work. But it is at the same time quite typical of Picasso that the depiction of this subject is not on a personal level, but interpreted through the world of mythology. Mother and son belong once again to a titanic race, larger than life and powerfully muscular. Their over-human stature is further enhanced by a device that Picasso often adopted—the figures extend almost to the frame itself, giving the spectator the impression that they are too tall to be enclosed in the space.

In this way an event in the life of the artist is translated into a representation of universal, mythological significance. It is indeed in the series of paintings around this theme that we can perhaps best see Picasso's tendency to create 'mythologies'—paintings that extend beyond the personal to the universal. They surpass the individual circumstance from which they were born; with their new vision of reality and truth, they cannot remain linked with the chance of their origins, but instead are transformed into forms of universal potency.

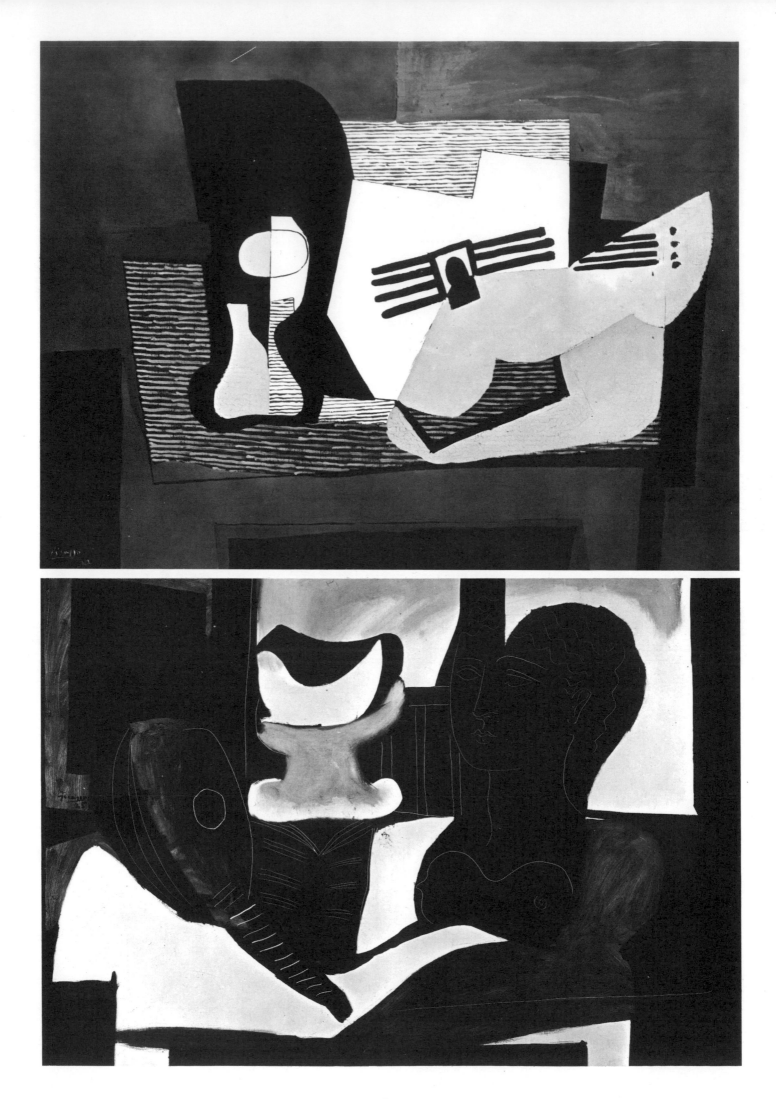

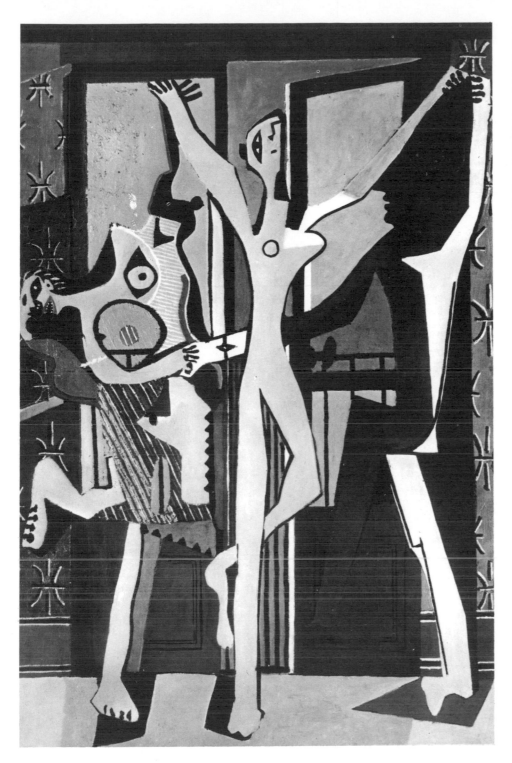

10 (opposite). *Still-life with a Guitar*
1922, oil on canvas
$32\frac{1}{2} \times 40\frac{1}{4}$ in (83 × 102 cm)
Siegfried Rosengart Collection,
Lucerne

11 (opposite). *Still-life with a Classical Head*
1925, oil on canvas
$38\frac{1}{8} \times 51\frac{1}{8}$ in (97 × 130 cm)
Museum of Modern Art, Paris

12. *Three Dancers*
1925, oil on canvas
$84\frac{5}{8} \times 56\frac{1}{4}$ in (215 × 142 cm)
Tate Gallery, London

This series was followed by another, in complete contrast to it: the por-
traits of little Paul, dressed in different costumes, as a bullfighter, a Pierrot
and even characteristically seated at his desk by the window. In these paint-
ings all the tenderness of a father for his son is directly evident, and it is
important to realise that Picasso retained nearly all of these paintings, as if
they were the pages of a diary that was not to be made public. The realistic
style of these paintings goes back to the portrait drawings of 1915, together
with a few elements from the last phase of Synthetic Cubism, that which
had found its most refined expression in *The Three Musicians*. Something of
the happy spirit that had stemmed from the themes of the *Commedia dell'
Arte* makes its re-appearance here in these various portraits of Paul in different
costumes, except that the interplay of ideas is more intimate and reserved,
just as if it did not take an outside observer into account. It is characteristic
that some of these canvases were never finished, although a skeleton drawing
provides a key to the intimate and highly personal quality with which he
endowed them.

The framework provided by Synthetic Cubism persists as a sort of con-

tinual accompaniment to Picasso's work: in 1917 it had been used for the first time in connection with stage design, and in 1921 it had been employed in the same field in the subject of the two versions of *The Three Musicians*. Towards the beginning of the twenties, Picasso became much involved with the theatre and ballet—in 1919 he designed the costumes for the ballet *Le Tricorne*, in 1920 those for Stravinsky's *Pulcinella*, in 1922 he collaborated with Jean Cocteau on *Antigone*, in 1924 he designed the scenery for the ballet *Le Mercure* and painted the backdrop for Cocteau's *Le Train bleu*. In all these works, which are now known only largely through drawings and sketches, Picasso returned to the principle of Synthetic Cubism in the overlaying of surfaces, which achieves a lively effect and a continually surprising richness of forms.

## Apollonian and Dionysian phases

Pls. 17, 18
Figs. 10, 11

Fig. 9

But this Cubist style which stems from the technique of collage was also to dominate another area of Picasso's work in the twenties—the still-life. The first works of the series date from 1924, although they go back to some minor works of 1919, and they take the theme of a still-life set on a table before a window which looks out to sea. Originally the artist chose an upright format for this theme, but gradually the emphasis shifts from the background to the level of the table and the objects in the still-life—musical instruments, a bowl of fruit and even sometimes a classical head, set against the sky or the wall which acquires a rhythm of its own and a brightness of colour from the pattern of the tablecloth. *Still-life with Guitar*, one of the first of this series, betrays its origins, which lie with collage. Its arrangement depends on a continual alternation of forms, structures and patches of different colours which are juxtaposed in much the same way as the pieces of coloured paper in the 1913 collages. The difference is that colour has now assumed a position of greater importance; in the earlier period the emphasis was on form without the interference of the consideration of colour. Now, on the other hand, through the influence of the theatre, the colours and costumes of the *Commedia dell' Arte*, colour regains its rightful place and very lively works are painted, although they could not be described as multi-coloured. Even if *Still-life with Guitar* does not equal the rich harmony and superb orchestration of some of the other works from the series, it is nevertheless a splendid example of the new complex polyphony which Picasso achieved in these paintings. As if in a musical polyphony, Picasso here creates passages in which the way the forms and the differential patterns (comparable to triplets or trills of quavers) are combined endows the work with a baroque movement that contrasts strongly with the ascetic quality of the earlier still-lifes. In spite of this, these paintings are dominated in all but the most light-hearted moments by a harmony which gives a classical impression, a special balance. In the even more sober paintings of 1925, such as for example *Still-life with Classical Head*, this contained harmony reaches a new peak.

Fig. 11

1925 also brings, however, the beginning of a very different trend. In *The Three Dancers* one can still recognise elements which go back to Synthetic Cubism and the collages. But these features are taken up with an altogether different purpose. It is no longer the intention to create a calm, balanced and self-contained harmony. We now encounter the freeing of the passions and vertiginous Dionysian movements completely the opposite of the Apollonian order that previously characterised Picasso's work. This conflict, which is the basis of this picture, may be recognised not only in the distorted forms of the figures in all their disarray but also in the colours whose violent and jarring tones present an impression of discord that is hard to reconcile with the harmony of the still-lifes of the same year.

Fig. 12

Once again we find Picasso expressing himself in two parallel styles, just as he had in 1921 in the two paintings *The Three Musicians* and *Three Women by a Fountain*. Once again each of the paintings, still-lifes on the one hand and *The Three Dancers* on the other, carries its own expression of life. We can see that the still-lifes represent a continuation of the Cubist idiom, where Picasso was seeking a new order out of the elements of painting that he had

already isolated—an order that is akin to a game but which at the same time has a profound meaning and is full of effects, such as the attempt to impose some order in the chaos which surrounds man so as to have a standpoint or example. Picasso's other work *The Three Dancers* is devoted to unleashed passions and Dionysian inebriation.

This painting is often connected with Surrealism which began during these years, but Picasso would strenuously have rejected any idea of this kind, even though he was in close contact with the leader of the Surrealist movement, André Breton, at this time and despite the fact that he participated in the first Surrealist exhibition in the Galerie Pierre in Paris in 1925. *The Three Dancers* has in fact no direct connection with Surrealism—rather both Picasso's painting and the Surrealist movement stem from the same sequence of events and from the disillusionment felt by those who had survived the World War in face of new divisions and strife in a world that had seemed so close to unity, but for the lack of human wisdom and spiritual discipline. Apart from this the figurative arts, like the other arts, sought an emotional release in the intoxicated dream-world of the occult, in the realms of fantasy and in outbursts of Dionysian sentiment. Picasso, like an unusually sensitive seismograph, was the first to register the tremors of the earthquake that was soon to come and to record them in his paintings.

**Years of the 'monsters'**

While Picasso continued to produce works in the Cubist idiom, the year 1925 and *The Three Dancers* mark the beginning of the artist's 'monster' period, which basically is none other than a reflection in figurative terms of the abnormalities of our age which no one up till then had been able or wished to record. This series of paintings reached its climax with *Guernica* in 1937, a painting which demonstrated the prophetic significance the whole series of works had had from the start.

But before monster-like distortions began to predominate in Picasso's work, the artist made a summing-up of the developments in his Cubist works in a number of further paintings. Once again they are figure representations, in which Picasso summarises the conclusions which he had reached as in *Fashion Studio* of 1926 and *Painter in his Studio* of 1926–7. In the first work, which is dominated by grey tones, the composition is subdivided by a series of curves so that the individual parts are linked together as if they were pieces of an inlay design. The resulting composition is dominated by the surface impression, since the linear effect and the lack of colour contrast place an emphasis on a two-dimensional impression. *Painter in his Studio* enhances this two-dimensional effect still further, with a painted frame and figurative elements within the composition that have no feeling of space, so that these features are more like hieroglyphs—the painter, his picture and his model (that is to say a table with a red cloth, a vase full of fruit and a plaster head), all set against the back wall of a room, with a door, a window and a mirror barely indicated. All this is reminiscent of mural painting, and indeed it was during these years that a number of artists, among them Léger, Le Corbusier and Ozenfant, introduced architecture into the realm of Cubist ideas and created a sort of mural painting dependent on the Cubist idiom but which by reason of its connection with architecture bordered on abstraction.

A surprising and yet characteristic side of Picasso's work, and one which makes repeated study of his works as fascinating as a first sight of them, is that the elements of his style are continually recast and placed in a different relation to each other, with forever changing effects. The same flowing lines which in *Fashion Studio* create an impression of grace and harmony also dominate in *Seated Woman* of 1927, one of the first works of the 'monster' period. Here the function and meaning of the lines are altogether different; together with strident and violent colours, they tend to convey and express a sense of oppression. Inexorably they enclose the figure of the woman and thus give the impression of containment, which is also reinforced by the placing of the figure in a limited space: it appears that the seated woman cannot change her position or get up. She is, as it were, in a cage. The impression of

Pls. 22–3

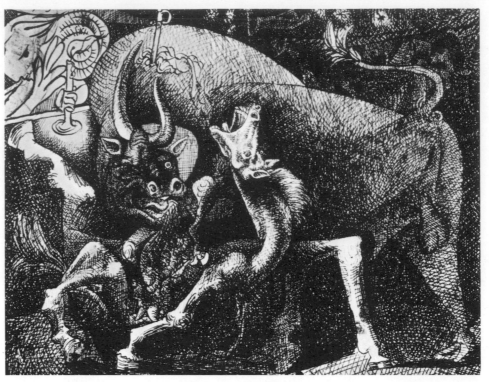

13. *The Bull-fight*
1934, ink on wood
12⅜ × 16 in (31·5 × 40·7 cm)

imprisonment is typical of all the works of this period. The face itself, which stands out against a darker form which is also part of the head, enhances the effect of oppression and anguish; it is like a Gorgon's head turned in the other direction, away from the spectator, but with an eye placed in that darkest spot and seems to stare out. As has been said above, this oppressive painting is the first of the series of monster-figures whose distortions make them the antithesis of any ideal of beauty, which has become a falsehood. Instead we are faced with demoniacal features that are clearly true, effective and in many ways also prophetic.

This painting is followed by a whole series of monster-figures—his *Bathers*, gesticulating in their striped swimsuits, painted at Dinard during the summer of 1928. Another painting from the same series, *Head of a Girl*, 1929, resembles a monument on a vast scale, its threatening profile standing out against the sky, its teeth menacing from above. What is perhaps the most anguished painting from the series also dates from this year—*Woman Seated on the Beach*. Here the human form is changed into that of a machine with but a single purpose—to attack and destroy. Its features are still reminiscent of those of a human figure, but its individual parts are those of a machine—the mouth, a toothed pair of tongs, the arms mechanical grabbers. Once again Picasso presents a prophetic vision of his own time, and subsequent events confirmed what he saw and what his contemporaries refused to recognise. The greater part of the monstrosities committed in the period around 1929 came about because all too often man reduced himself to the level of a machine, and with the technical perfection of an efficient machine committed murders, aggression and destruction. Picasso foresaw and understood this phase of our history and showed his understanding to be prophetic, that of a moralist who comprehended the errors of his time. His deep feeling of human sympathy enabled him to reveal the dangers and threats which he saw in a vision that was grandiose and at times apocalyptic.

## Metamorphoses and the Minotaur

The horror of *Woman Seated on the Beach* marks an extreme point which Picasso did not exceed even in his most anguished representations. The phase of 1930–1 represents a complete renewal, a new direction in his work. In 1930, he bought the little Château Boisgeloup, near Gisors, to the north of Paris, and devoted himself with the help of his friend, Julio Gonzales, to making a studio for sculptors there.

He had already, before 1930, sculpted small pieces of wood and made three-dimensional compositions with wire, but he now felt the need—we

can see this clearly in paintings like *Head of a Girl*—to work with solid forms. From these years date his iron sculptures which reveal a strange metamorphosis of forms—metal strips suggesting human limbs, constructions made with slender bars giving a strong impression of space. From the same period, although in an entirely different spirit, there are some massive heads which show Picasso's objective of creating sculpture with all the force of the third dimension. The sculpture which Picasso created with the assistance of the sculptor-blacksmith, Julio Gonzales, has an altogether different significance. These pieces are rather drawings in space which suggest a multiple complexity of forms and present possibilities for development as much in painting as in sculpture. Through the importance which metamorphosis has in these works, we can understand why Picasso was attracted at this time to the idea of illustrating Ovid's *Metamorphoses*. Picasso's illustrations to this work are imbued with an almost classical spirit, employing the sort of thin and tense line found in early 19th-century drawings, but with an additional mobility and flexibility that contrast superbly with their tenseness.

The illustrations to the *Metamorphoses*, thanks to their classical style and perfection, might appear to mark a culminating point, but instead they come at the beginning of a new phase in Picasso's work. This is true not so much with regard to the expressive means at the artist's disposal, but rather with regard to the social and human content. It was during these years that his matrimonial difficulties with Olga Koklova reached a crisis point which was to be finalised by their separation in 1935. In the meantime a young woman came into Picasso's life, who was to bear him a daughter, Maia. This young woman, Marie-Thérèse Walter, had been the model for the heads Picasso had sculpted at Boisgeloup, and also for a series of paintings that were executed around 1932. These show the young girl asleep or dreaming, relaxed in an armchair, unconsciously exposing all the charm of her young body. It must have been the harmonious simplicity, the almost plant-like life of his young model that attracted the artist, during a period which he himself described as a *saison en enfer*. Sculpture and painting are continually reciprocally influenced by each other during these years. This mutual enrichment is apparent not only in the relationship between the heads sculpted in 1931 and the series of female figures painted in the following year, but also in the amazing similarity between the still-lifes of 1931—painted with broad black curving lines enclosing areas of strong colour in much the same way as the leaden seams of medieval glass—and the iron

14. *Sketch for Guernica*
1937, pencil
$9\frac{1}{2} \times 17\frac{3}{4}$ in (24 × 45 cm)
Author's Collection

Pl. 24

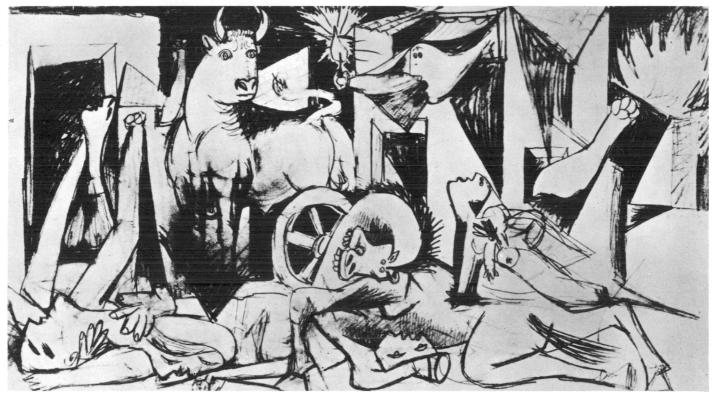

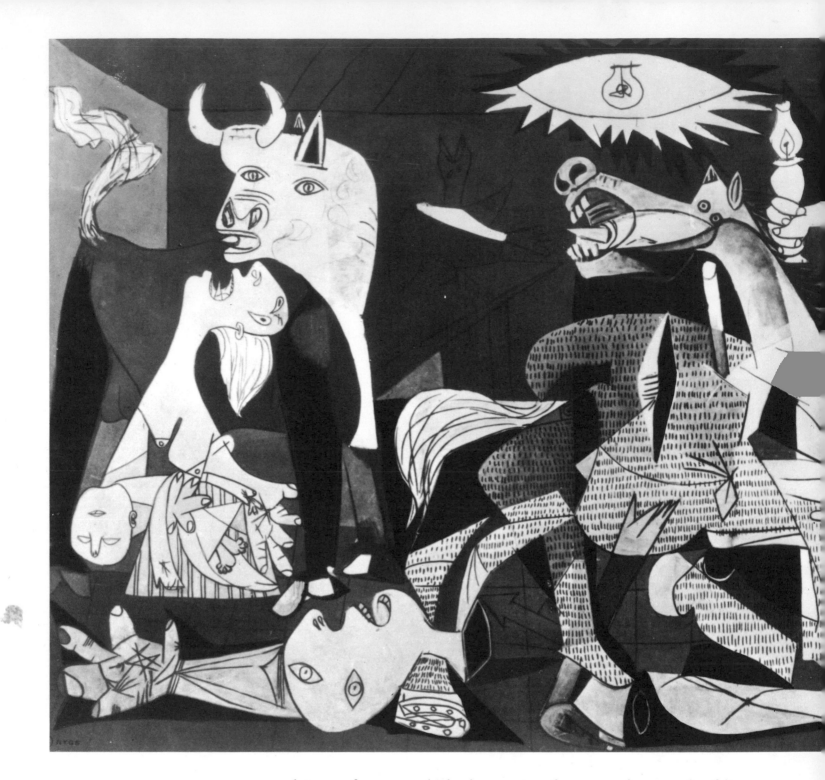

sculptures of 1931–2 which also consist of a strong framework of lines conveying impressions or surfaces, spatial relationships and figurative values very similar in impact.

Picasso's personal mythology takes on a clear form from 1931 onwards. He had been seeking a way in the illustrations to the *Metamorphoses* and had prepared a sketch for a Crucifixion with the idea of finding a language capable of expressing anguish and drama. But the solution did not come until a number of years later, out of reality, 'his' reality. In 1934 he travelled again to Spain, still seeking a subject which could express all his pent-up emotions. He found it in a subject which was not altogether new to him and which he Fig. 13 had used around 1901—that most characteristically Spanish pastime, bull-fighting.

He returned to Boisgeloup and painted a series of paintings in which the most dramatic moment of the bull-fight is shown. In portraying the climax of the struggle, sentiments such as terror, impotent compassion and brute strength are given figurative form and immediately compel the spectator. The following year, in 1935, the subject acquires a directly mythological

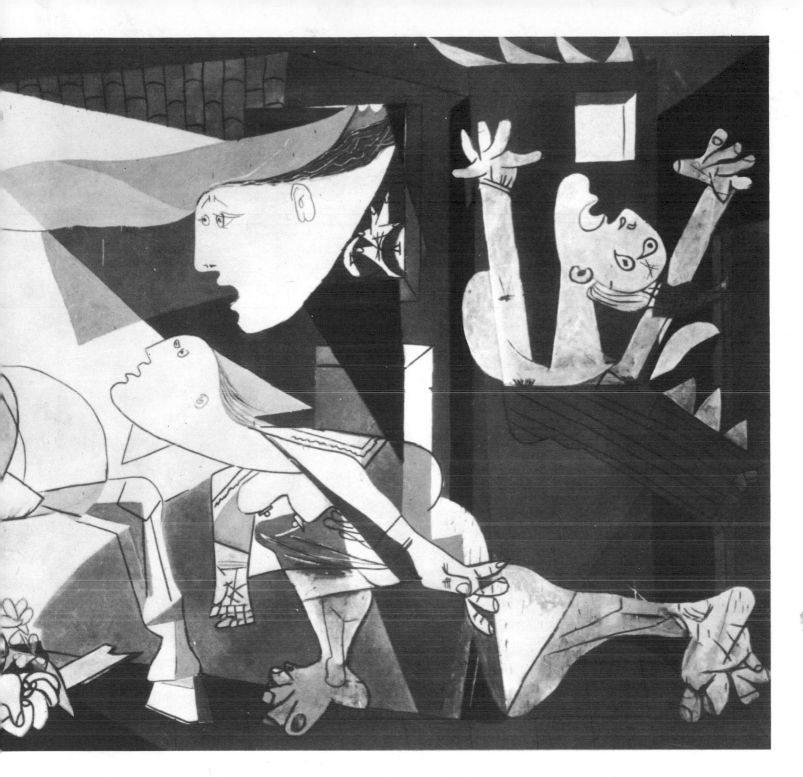

significance—for the first time the Minotaur, the man-bull, appears in Picasso's work, and in the superb etching of that year we see its characteristic gesture, shading its eyes from the light of a candle held out by a small girl. A number of features and figures are recognisable from the bull-fight sketches of the preceding year; what is new in 1935 is the imposition of mythological meaning.

In 1936 the myth became a reality with the beginning of the Spanish civil war, and the Minotaur no longer only shades its eyes from the light but puts it out wherever it finds it and tramples on those who bring it wherever it finds them. Picasso, who as a human being and as a Spaniard was doubly hit by this violence, immediately turned to the support of the legitimate Spanish Republican government, which made him Director of the Prado and responsible for the safekeeping of the artistic heritage of Spain. At this very time he had a travelling exhibition in Spain which had been organised by his friend, Paul Eluard, who had chosen the paintings, and this must have increased his attachment to his country. The events in Spain, which he still

15. *Guernica*
1937, tempera on canvas
11 ft 6¼ in × 25 ft 7⅞ in (3·51 × 7·82 m)
On loan to the
Museum of Modern Art, New York

## Betrayal by Franco

16. *Portrait of Nush*
1937, oil on canvas
$36\frac{1}{4} \times 25\frac{5}{8}$ in (92 × 65 cm)

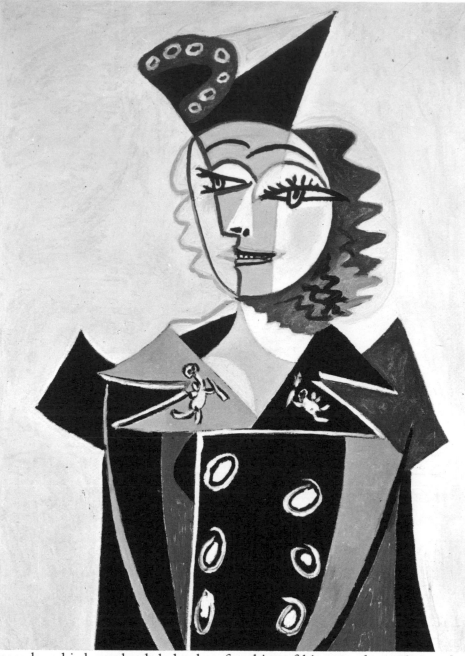

regards as his homeland, helped to free him of his own depression and to return to a normal state of mind. His depression stemmed from his private life and almost prevented him from painting for nearly a whole year. During this time he also wrote some poetry at Boisgeloup, which showed that his artistic imagination was not only limited to visual forms but also found an effective medium in words.

As has been said, he was torn away from this escapist frame of mind by the events in Spain. At the beginning of 1937 he participated for the first time in the civil war with the publication of his series of prints *Sueño y mentira de Franco (Dream and Lie of Franco)* in which for the first time he directed his mythological imagination against the figure of the usurper and the tragedy which he was causing. The prints, which are divided like popular prints into nine scenes recounting the grim tale, are accompanied by a satirical text by Picasso, which does not lie. It was perhaps these prints which prompted the government to commission Picasso to execute a great mural for the Spanish pavilion at the 1937 World Exhibition that was to open in the summer. In April of that year Picasso had not yet begun work.

That month, on 28th April, 1937, an event took place which shook the whole world: the bombing of Guernica, traditionally the capital of the Basque region, on a market day, by aeroplanes of Nazi Germany in the service of Franco. This assault by the Fascist collaborators was the first terrorising raid, directed not against foreign soldiers but against unarmed

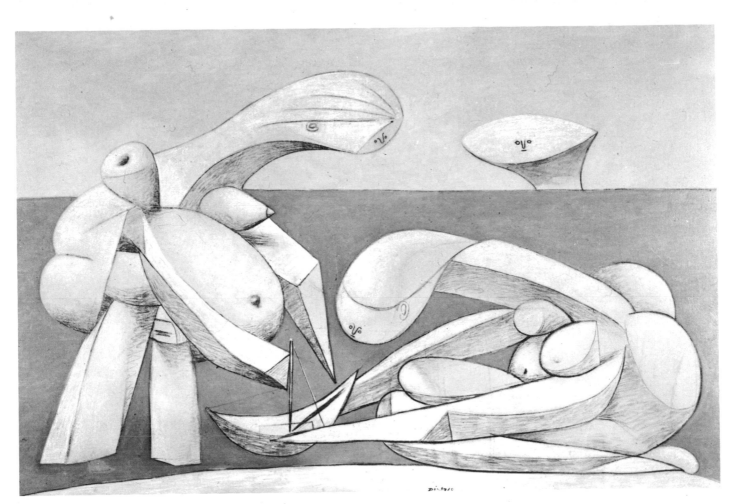

17. *Bathers*
1937, oil on canvas
$51\frac{1}{4} \times 76\frac{3}{4}$ in ($130 \times 195$ cm)
Guggenheim Collection, Venice

Fig. 14

Spanish citizens, including women and children. Picasso too was shaken to the core. His reaction was more human than political, more that of a moralist than a partisan. On the 1st May he began the sketches for the great canvas he was to paint during the early days of that month in his studio in the rue des Grands Augustins. The first drawings include all the mythological references that appear in this vast and monumental work – the dying horse, the bull, the dead warrior and the woman in flight. One of the first parts painted in colour and in oil clearly shows how Picasso's contained anger and hate, strong enough to take one's breath away, lost none of their intensity from the beginning to the end of the work. But while the general intent and meaning of the work remained unchanged, it underwent many transformations from the original drawings through to the final painting. The respective positions of the various figures are different, the body of the bull makes a new half-turn, and even the body of the warrior follows a different pattern. Picasso wanted to express his allegory in a format that would be universally valid. He soon found this form: it was to be the triangle, like the façade of a Greek temple.

Fig. 15

The figures are placed within this triangle, the dead warrior at the foot of the composition and the other figures, the woman fleeing from her house in flames, the other woman with her dead child, forming the sides and the content of this great area that has the same dramatic power and in many ways a similar concept of human destiny as ancient temple pediments. In *Guernica*, which together with Calder's *Mercury Fountain* and a work by Julio Gonzales gave the Spanish pavilion such an impassioned character, Picasso was not just representing the single event of the bombing of the town; he elevated the happening to the sphere of the universal – to a mythological level, just as he had done before in the series devoted to the theme of maternity. It is difficult to read this work and the symbolic importance of some of the figures, especially that of the bull, has been the subject of extensive discussion. The monumental impact of this painting (which stems from the graphic symbolism of the broad areas of paint in which colour plays very little part, being reduced as it is almost to *grisaille*) is directed not so much against

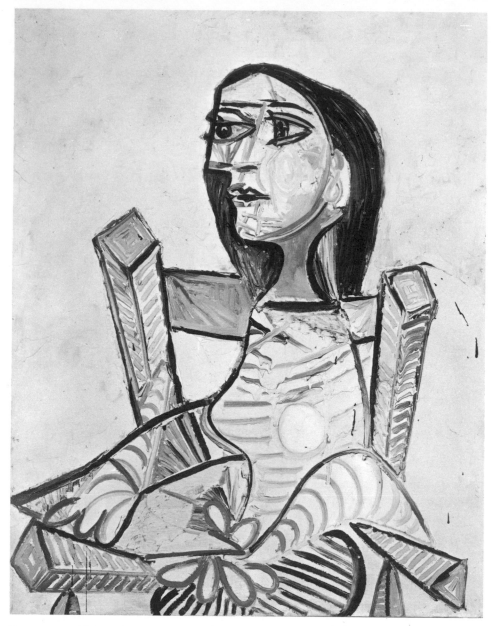

Franco and his grim company, but intended rather as a lament for the loss of liberty and freedom, against oppressors and murderers generally. History was soon to show how right Picasso's prophetic vision was: what was to prove important in the following years was not so much Franco and the cruel way in which Guernica had been destroyed, but the unleashing of evil and the dark forces which Franco and Guernica had symbolised. Guernica was only the first step in a way that was to be littered with names such as Warsaw, Rotterdam, Coventry, Sidice, Auschwitz and so many others which for the men of this century fill the memory with horror.

Picasso is one of the few great figures of his generation who not only recognised this side of the history of his time but who saw it in advance and tried to warn humanity. He must have felt like one of the Old Testament prophets, driven to speaking out sometimes even against their will. An anecdote which is revealing as to Picasso's attitude during the war tells of his handing out postcards of *Guernica* to German officers who came to find him. To their surprised enquiry 'Did you do this?' Picasso replied 'No, you did', the stony reply that might be that of the Sphinx or one of the Fates. *Guernica* marks the culmination of the mythological phase in Picasso's work, a synthesis of all his work from 1934 onwards. This also included a whole series of individual works, which have been called '*post scripta* to *Guernica*' by Alfred H. Barr and of which *Weeping Woman* with its expression of infinite anger and tragic grief is perhaps the most powerful. Its force and immediacy links it closely with the first sketch for *Guernica*, the one with the head of the dying horse.

Pl. 29

36

In the two following years this apocalyptic state of mind continued and was of course justified by the turn of events – the false peace made at Munich and the fall of Czechoslovakia foreshadowing what was to come. *Girl with a Cock* and *Portrait of Maia with a Doll* continue this 'monster' series that began around 1930, but now the monsters are no longer merely prophetic scarecrows, but all too apparent as part of an everyday reality.

Pl. 30

A little before the War, during the summer months of 1939, Picasso painted a work at Antibes which brings this period to a close. This was the painting *Night Fishing at Antibes* (sometimes known as *Fishermen at Antibes*), dominated by a cruel and violent scene in the centre of the composition: fishermen harpooning and impaling creatures in the dark water by the light of great yellow lights that seem almost to be artificial suns. The scene is made more dire and sinister by what Picasso has shown in the rest of the painting: to the right there are two children holding bicycles who watch dispassionately what is happening (one of them is eating an ice-cream), with the sleepy profile of the towers and houses of Antibes standing out against the sky in the background. The colours – green, violet and a poisonous yellow, set against an almost black background – provide the key to the state of mind which emanates from the painting, which is a night-piece not only in its subject but in its expression more especially of the very darkest tones of its time. It marks an abandonment of the period of light and clarity and foreshadows the dark cruelty of a murderous age. Chance would have it that in these very months, Picasso's fame was being extended to America thanks to a great retrospective exhibition at the Museum of Modern Art in New York, while the silence of the grave descended on Spain and soon also on his second homeland, France. Picasso spent the war years and the period of Nazi occupation of Europe in anything but the role of a famous artist; rather he was a man who had taken an open stand against the violence and barbarism that oppressed Europe and so could regard himself as continually threatened and under suspicion. He had made not a single concession to the invaders and during these years he isolated himself almost completely, devoting himself entirely to his work.

**Night Fishing at Antibes**

Pl. 31-2

After the declaration of war in 1939 Picasso at first sought rest and refuge in the seaside resort of Royan, at the mouth of the Gironde. Here he painted some landscapes whose luminous colouring and freshness of handling seem to belie the period in which they were created. But the very joyousness of these paintings is typical of Picasso's genius. When he writes that he thinks neither of the past nor of the present, but that he paints solely for the present, these are not empty words nor a chance remark but the very truth. When shortly after the outbreak of the war he saw the bright colours, the sails of the boats and the lively atmosphere of a fishing village, this was a reality for him, the reality of that moment, and he felt impelled to grasp and record it. This polyphonic aspect of Picasso's work, with the simultaneous presence not only of different styles but also of different subjects and contrasting states of mind, is not only the result of a lively imagination and phenomenal virtuosity, but also and principally the outcome of a persistent and tenacious search for authenticity. Picasso refuses to remain tied to a formula even when it is one of his own invention; he wants to represent and externalise what moves him and fills him with enthusiasm, like the old saying, 'What fills the heart overflows from the lips'. In the days following the declaration of war he was full of the bright and happy colours of Royan; he had freed himself in the spectacular work he had painted at Antibes of his fears and premonitions of the war that was approaching.

Pl. 34

But his stay in the country, far from Paris, was not to last long. During the occupation of France, a time of oppression and silence, Picasso was in Paris in the solitude of his studio, devoting himself entirely to his work. He takes up two themes during this period; the first having as its subject, in a whole series of paintings, a young woman always differently dressed seated in a

**A weapon for attack, a defence against the enemy**

Pls. 35, 36

Pl. 38 very meaningful posture in an armchair, sometimes set in the middle of a room but more often in a corner. To describe the young woman as seated in the chair is to miss the real point; she is rather imprisoned in it, hemmed in between the arms and the back, strapped in as it were in an electric chair. The same impression of imprisonment, the impossibility of escape from a cage–the chair is only a chair in material form–is also conveyed by the hands which are joined convulsively, by the twist of the head with regard to the body and by the position of the chair in the room, from which there is no imaginable escape. The atmosphere of this series, in which there are some examples such as *Woman in a Hat with a Fish* that reveal a strange humour around the theme of execution, faithfully records the state of mind that dominated France during those years. The other series, one of still-lifes

Pl. 33 with bulls' heads, stems from a particular interpretation of *Guernica* and may be regarded as an extension of that work. Only the skull remains of the savage beast in this composition, but its horns, still threatening and danger- ous, seem to pierce the space of a room filled with a fearful violet twilight. The threat which everyone felt in those years was given visible form in certain features such as the posture of a figure or two hands clasped together. In this way Picasso is not only a chronicler of his time, but also one of the personalities who helped to shape the images of this century.

Alongside these two series of paintings, his other work also progressed, particularly his sculpture. And it was the very theme which so fascinated him in this period–the skull of a bull–which gave him the inspiration for one of his most disconcerting creations. By joining together the saddle of a bicycle with its handlebars, Picasso created a powerfully magical form, that of a bull's skull in its barest essentials whose formal simplicity makes it comparable only with African masks. What had happened when Picasso fashioned this mythical mask of a bull? He had made a real discovery, which consisted in noticing something no one had before him: that two objects from ordinary life, meaningless apart, could be filled with magic when joined together. From everyday language he had adopted two words in a figurative sense and created a new metaphor, a new image. He had given new life to an old artistic device–metamorphosis–whereby, while the form of a given object undergoes no change, its meaning is altogether changed; from the saddle and handlebars of a bicycle a bull's head emerges and no one thinks of the parts of a bicycle any more.

All these works, numbering 74 paintings and 5 sculptures, were shown to- gether in the great exhibition which French artists organised for Picasso at the first Autumn Salon after the Liberation in 1944. It was a tribute to the strength of purpose of a man who had kept his bearings and had resisted the attacks and enticements of the oppressors. It was, above all, a tribute to the persistence of an artist who had carried on regardless with his work in despite of the anguish and suffering of his time. He had continued to create works in figurative language as far as he could, and when that became im- possible he turned to literature. In 1941 he wrote a Surrealist play: *Le désir attrapé par la queue*, which was performed in the house of his friend, Michel Leiris, in 1944. It is of especial interest to observe the relationship between this work and his figurative creations of the same period: its effect is reached through the same means that we can observe in the sculpture in the form of a bull's head, by the metamorphosis of things, words and concepts.

But even while the exhibition was held in Paris, Picasso's work had taken another step forward. It is characteristic of the way in which he would find figurative interpretations of the events that he saw before his eyes that he should have made a free copy of Poussin's *Bacchanal* during the exciting days of the liberation of Paris; it was a work which, to his way of thinking, best expressed the exuberance of the moment. Later, looking back on the years of the Resistance, he joined a political party and became a member of the French Communist Party. It was in connection with this event that there took place the interview of which we have already quoted a part at the beginning of this text:

'What do you think an artist is? A fool who when he paints has only eyes, when he writes music has only ears, when he writes poetry carries a lyre in each corner of his heart or when he is a prizefighter is all muscles? No, he is a man who is interested in and even participates in politics, fully conscious of change and of the amazing events in the outside world, one who responds to it all with all his being. How is it possible to remain indifferent to other men, or to set oneself apart from life in a proud isolation? No, painting is not created for the decoration of houses, it is a weapon for attack, a defence against the enemy.'

Picasso's artistic production during these years is closely linked with this declaration and the inner attitude from which it stemmed. In the first instance there is that very earthly representation, *Man with a Lamb*, a work which presents the theme of the Good Shepherd in a new secular form, testifying to the eternal link between man and animal. Also dating from the period following the Liberation, there is a series of still-lifes culminating in a marvellous canvas with a jug, candlestick and blue enamel saucepan on Pl. 37 a wooden table. This sober and harmonious composition owes its vitality to the dignity with which Picasso imbues the simplest articles from daily life – or rather because he reveals them in their true dignity. Almost everyone during the war years had, through loneliness or confinement in some hiding-place, discovered the dignity and value of simple objects that often took the place of friends and families in the affections. Picasso shows three objects on a table with precisely this – we must use this same word again – mythological intent, at the same time creating one of his most attractive still-lifes.

In order to achieve this effect of revered simplicity, Picasso made use of a technique that goes back to his Cubist days and which we know mostly from the still-lifes from around 1930: a technique which recalls once more the strong black outlines of stained-glass windows with their areas of colour surrounded by leaden seams. A similar technique is also characteristic of another almost contemporary series, which is a series of views of Paris. Each one of these is a tribute to that heroic town, which by a miracle had escaped destruction. Picasso rediscovers it in all its beauty: the island with Notre Dame in the background, the green park at the end of the Ile de la Cité, crowned with the monument to Henry IV. Some of these pictures have the same vitality as medieval stained-glass thanks to the artist's limiting himself, as the medieval artists did, to a single colour, such as various shades of blue.

The imposing of limitations, even in the area of technique, played an important part in Picasso's work at this time. In 1945 the greater part of his creative endeavour is spent in the field of lithography, which he had ample opportunity to work at in his studio at Mourlot. A great number of prints appeared during this and the following years; most often they came in series starting from direct observation and passing through numerous intermediate stages before reaching the simplest symbolic representation – a hieroglyph. These include representations of a bull, the ever-simplified forms of a human figure, and later a series of an owl. The artist's principal objective is the search for the simplest form, omitting all unnecessary details and concentrating on the essential.

## Ceramics

These experiments were a great help to him when he came across a new world in the south of France, an unheeding world of pagan joy in life which he had thought was lost for ever. This is the subject and the title of the great painting, *Joy of Life*, that is his masterpiece from the autumn of 1946. The director of the museum at Antibes, where Picasso had returned to live, had asked him to give one of his paintings to the museum and with this in mind had taken him round the gallery. As Picasso could not conceal his enthusiasm for these rooms, the director allowed him to use some of them as a studio, and it was here that he created a series of works on synthetic panels in which he revealed his most vital feelings during those years. Once again the subjects are mythological, but with an opposite meaning to that which Picasso's

*19. Les Demoiselles au bord de la Seine*
1950, after Courbet, oil on canvas
$39\frac{5}{8} \times 79\frac{1}{8}$ in ($100 \cdot 5 \times 201$ cm)
Kunstmuseum, Basle

mythologies had ten years earlier. What had been despair and anguish is now the joy of life and happiness, a tonality in a minor key is converted to a major one. Goats dance in circles in a sunny seaside landscape and centaurs and small fauns play flutes around the figure of a dancing woman; these scenes of southern joy are often a tribute to women and in this case to Picasso's new companion, Françoise Gilot, whom he had married in that year. Once again an event in his own life is raised to mythological significance, and one is struck how many of these paintings and especially the principal one, are based on the same triangular composition, comparable to a Greek temple pediment, that we find in *Guernica*, although there of course the content is entirely different and the tonality in a minor, not a major key. The artist's stay at Antibes had another result that came about through his meeting with the Ramis family which ran the Madoura ceramics factory at Vallauris, on an excursion inland. His attractions to the medium and his realisation of its possibilities were not, however, immediate and date from 1947. To start with, his ceramics continued the themes of his paintings at Antibes: the same fauns and happy pagan figures that peopled the great paintings of the autumn of 1946 now appear on bowls, jugs and all sorts of receptacles. Soon we can see that the material and technique of ceramics influence his other work, just as always happens with Picasso. The softly shining colours of the ceramics reappear in his paintings, above all in his still-lifes, which acquire a new radiance, as if they were lit by a new light. Nevertheless the range of colours is barely changed; it is only that the colour is applied in a lighter and more luminous manner, with the gentler touch that is necessary and inevitable with a different base material such as clay. Later Picasso created works in which he did not limit himself merely to the decoration of ready-formed pieces; these are creations truly in the medium of ceramics itself, which Picasso learnt and mastered in the space of a single year. The nude forms of a young woman are fused into those of a jug; on some plates fish and cuttle-fish appear to have left the impression of their forms almost without the intervention of an artist. But it is precisely this aloofness of the artist's hand which shows how much Picasso identified his artistry with the nature of the material. And when Picasso later created some small sculptures in pottery—some owls and pigeons—it is clear from the individual expression he was able to give to each piece that he was a master of this material, a master full of ideas where others groped in the laborious pursuit of originality. The dove of peace Picasso designed in 1949

for the Peace Congress held in Paris is closely connected with this side of his creativity; it has flown throughout the world and has become universally known for the symbol it is.

This period of intense artistic activity continued for several years, and was only interrupted by a journey which Picasso undertook on account of his faith and conviction in a better future to the Peace Congress at Breslau in Poland, which was the forerunner of the one for which he created the famous dove. A feeling of joyous happiness dominates all his work, and this was doubtless enhanced by the birth of his son Claude in 1947 and of his daughter Paloma in 1949. In 1948 Picasso took a house at Vallauris so that he could devote himself more fully to ceramics, and in the same year an exhibition at the Maison de la Pensée Française revealed the variety and artistic and technical worth of these creations, which were sincerely admired by all who saw them.

Towards the end of the forties and in the middle of all this enthusiasm for ceramics, a new subject began to attract Picasso's attention – the free rendering of the masterpieces of the past. The first example of this new direction is his copy of the *Demoiselles au bord de la Seine* by Courbet in the Petit Palais in Paris – the first, that is to say, if one excludes the copy of Poussin's *Bacchanal* from the days of the liberation of Paris. This latter work had been mainly an expression of the unbounded joy reigning in the city at the time, of which Picasso found expression in the reminiscence of Poussin's Dionysian scene. But now what matters for Picasso is not so much the opportunity for the expression of a state of mind as the desire to measure himself against the masters of the past and to fathom their secrets. Almost contemporary with the copy of the Courbet is a version of El Greco's *Self-portrait* in the Museum at Seville, and it seems no chance similarity that the attitude and character of this painting vaguely recall Picasso's self-portrait of 1906. The extent of the derivation in the case of both the Courbet and the El Greco are characteristic of Picasso's reliance on his original material – that is to say that the relationship is a very free one. He himself once said 'I treat paintings as I treat things. If there is in a painting a window which does not please me, I shut it and draw the blinds, just as I would at home.' The freedom which he felt before paintings and towards things in general is also in evidence in his versions of the works by Courbet and El Greco, and later of other artists, since he realised that he was dealing with his equals and that he was, just as Baudelaire had written of Delacroix, a link in the centuries-old chain of the history of painting which would be broken if his work was omitted. Both the version of the Courbet and that of the El Greco bear witness to this freedom, a freedom that could only be contemplated between artists of the same level and standing. An ordinary copyist would never have dared to paint his version of the Courbet on a canvas that was considerably larger than the original, but Picasso did not hesitate to do so for he felt that he could do better justice to Courbet's work in this way. Nevertheless, he follows his model in all its essential details although he translates them into his own idiom, so that El Greco's *Self-portrait* is transformed into a real Picasso creation. One should speak not so much of copies as of interpretations, like those which Vincent van Gogh made of works by Delacroix and Millet, starting with a given theme and producing a work imbued with his own understanding of it, but always with the intention of remaining faithful to the spirit of the work, rather like the musician who plays the work of a composer but with the intention that his own personality should also be apparent. The 'interpretations' which Picasso made of works from the past from 1950 onwards have an important place in his art and his working methods subsequently changed significantly.

While he worked on his studies of the great masters of the past and on his creations in the field of lithography and ceramics, he also took up sculpture again. From this period date the sculptures of a large goat and a baboon,

## Masterpieces from the past

Fig. 19

## Sculpture

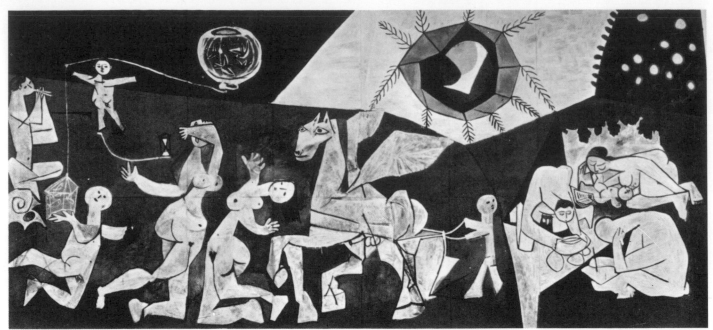

*20. Peace*
1952, oil on isorel
15 ft 5 in × 32 ft 9¾ in (4·70 × 10·20 m)
In the Temple of Peace, Vallauris

which show the same sort of technical exploration that we find on the one hand in the *Head of a Bull* of 1943 and on the other in his collages of 1913. There are the two aspects present, both the aspect of metamorphosis or transmutation of forms, and that of discovering objects from a point of view which had not been adopted before, giving them new meaning. As with the collages, Picasso creates these sculptures out of ready-made components: the body of his *Goat* is a great rush basket and its teats are those oil and vinegar containers that have a place on every French dining-table. This inventive juxtaposition is carried even further in his *Baboon* which dates from the following year, 1951, in which the nose is formed of two toy cars. This highly individual and quite characteristic working method is exceptional not so much by reason of the choice of objects, but because of the complete transformation which they undergo, so much so that the toy cars 'become' the nose of a baboon and the oil and vinegar flasks are actually the teats of a goat to an extent that no one would suspect their real identity. The art-historian has to make direct reference to these things not in order to give the secret away, as it were, but to point out a state of mind that belongs as much to the 20th century as to Picasso and his fabulous imagination. Picasso found that he did not have the time, nor indeed perhaps the patience, to fashion for himself every part of his works, especially as he could rely on finding what he needed elsewhere. And he can really evoke diverse forms even in the most improbable circumstances, since he is able to perceive not only the forms which objects assume in daily life, but also all those images and ideas which a form may suggest. Just as he does not allow his freedom to be constrained by tradition, so he does not allow day to day routine to predominate over his extremely fertile imaginative association of forms. So these years also saw another facet of Picasso's work come into play—his sculptural imagination—which was displayed in the same year (1951) at an exhibition at the Maison de la Pensée Française.

## Massacre in Korea<br>War and Peace

This joyous pursuit of imaginative fantasy was soon interrupted, as had already happened once before, by events in the outside world which forced Picasso (and Picasso himself put it in this way) to adopt a stand and make it known. The events were the outbreak of war in Korea, and Picasso's re-action was contained in the painting *Massacre in Korea*. Once again, as had been the case with *Guernica* and with other works, the painting did not become a political manifesto. Picasso did not take sides and instead raised his voice against evil—in a manner that was very Spanish. He based his composition indeed on Goya's *Execution of the Rebels on 3rd May, 1808*—a work in which Goya had set himself the task of representing the annihilation of liberty by brute force. In Picasso's painting, however, the victims are not

rebels; the group of figures (which is strongly reminiscent of the arrangement of those in Goya's painting) consists of nude women and children playing, which lends additional weight to the dramatic contrast. We can also see the extension of the analogy with Goya in another side of Picasso's work from his reply to a question asking why he should have represented the fearful scenes of *The Disasters of War*: 'So as to have at least the satisfaction of continually exhorting men not to be barbarous'. This painting, and two more the following year, are the result of this state of mind.

The latter two works are two enormous murals which cover the lateral walls of an old chapel at Vallauris, which the town council had asked Picasso to set in order and which he wanted to convert into a 'Temple of Peace'. In the square right in front of the chapel there stands his statue of the *Man with a Lamb*, which he had presented to the town. The two murals contrast the harmony which was Picasso's eternal dream and the horror which he had frequently experienced. In the one painting, *War*, an apocalyptic chariot advances, drawn by infernal horses which collapse and die in front of a standing warrior, who guards himself with a shield against this assault. The painting is in harsh discordant colours with contrasts between blood-red and black and a poisonous green. The other painting, *Peace*, shows a world in which all is possible; the central symbol is a winged horse–Pegasus of the old legend–which stands for poetry and mythology, led by a child holding its reins. Standing around there are a number of figures which closely recall his great painting *Joy of Life* (especially the flute-player on the left) and make an idyllic *tableau* before a blue background. One side of the painting symbolises the act of contemplation (the calm Apollonian side of that fortunate state), while the other, acting much as a counterbalance, shows an ecstatic dance which at the same time raises Picasso's idea of the two sides of human life to a mythological level. The same tendency can be observed in other paintings, drawings and graphic work of the same period. The darker and more anguished side of Picasso's temperament finds its expression in still-lifes, which often have a slender ghostly goat's skull and are usually painted in dark colours and drawn with harsh angular lines. They convey an impression of oppression, anxiety and internal anguish through their linear rhythms and dull colours. The lighter side of Picasso's imagination is given full rein in paintings of his family, and here too what we have is not so much a representation of his two youngest children, Claude and Paloma, as an almost mythological rendering of the most universally valid moments of family life: meal-times, play-time and other similar moments in children's lives with their parents. These works play the same role as those he painted at the beginning of the twenties on the theme of maternity, prompted by the birth of his first son. The palette is strong and simple and dominated by pure primary colours–red, green and blue–and the linear design also makes use of the same simplicity that speaks for itself. The areas of colour are enclosed within broad geometrical shapes, often only differentiated from each other by mere hatching, so that the image stands out and makes the most direct and clearest possible impression. Possibly Picasso was influenced by drawings made by his own children, not so much by their style but rather by their clear and simple description of events and forms, by their calligraphy striving to represent reality.

## Cycles and Variations

Although in his work Picasso derives general values from the events of his own life, this does not mean that such events do not affect him. In 1953 he had to break with Françoise Gilot, his companion of the previous years and the mother of his two youngest children. This certainly made a big impression and brought a change in his daily life; a parallel change can be seen in his work. This change is also undoubtedly due to the fact that during these years a series of exhibitions of his work were held in 1953 at Lyons, Milan and the Musée des Arts Décoratifs in Paris and also at the Bibliothèque Nationale the following year. These exhibitions must have provided Picasso with a perspective of his work and given him the opportunity for a re-

Fig. 20

Pl. 39

assessment of the problems he had faced and the solutions he had reached. After this, he turned to new subjects and new problems; he also bought a new house in order to start a new life. The new house was the villa La Californie at Cannes which he bought in 1953, and which became the background of his life but also at the same time the subject of a series of paintings which take the artist's studio as their point of departure and deal with several aspects of it.

But the most important subject-matter during these years was to remain his exchange with the masters of the past—a free interplay with the ideas which they provided although always using certain rules as guide-lines. In a way, this took up a trend which had started with the free copy of Poussin's *Bacchanal* painted following the liberation of Paris and continued in the copies he had made of El Greco's *Self-portrait* and of Courbet's *Demoiselles au bord de la Seine*. The work which provided an impetus for the new manner was an engraving by Cranach around which he did a series of variations in some prints. There followed the really important discovery of that masterpiece full of warmth and colour by Delacroix, *Les Femmes d'Alger*. What is different now about Picasso's interpretations of a masterpiece from the past, and what is new about his working method is that he does not restrict himself to making merely a free version of the original but rather takes from it the inspiration for a whole cycle of paintings.

This habit of working in cycles seems to become increasingly common in the following years. The clearest parallel that can be drawn to explain the artist's work and also his intentions is the musical form of the variation, such as we know it, for example, from the fascinating series of compositions Brahms composed from themes by Handel and Haydn. In these works the variation extends not only to the rhythm, harmonic structure, tempo and tonality of the musical theme, but also involves an analysis of the various elements of its structure and composition. Picasso does the same in a series of works, none of which can be regarded as a 'definitive' statement on the original, the more so since it is characteristic of the later work of Picasso (as of the late Rembrandt) that the concept 'definitive' no longer applies. He sacrificed it in favour of the cyclical method of working in which the individual pieces form a whole only together, like a series of arches. When seen as a group, they provide a richer interpretation of the original which provided the inspiration than any single work which Picasso might have devoted to the understanding of a painting by one of his great predecessors. And these cycles should be regarded much more along the lines of musical variations, as analyses of structures, than as simple translations into Picasso's own terms.

Pl. 40–1  Picasso began this new style with the series of variations on Delacroix's *Les Femmes d'Alger*. In each one he takes a different view of the original painting, to which he must have been very attached. In one version it is the colour which predominates, in another the painting's decorative structure, in yet another the artist concentrates on the feeling of warm and passive sensuality which emanates from it. The fifteen versions of Delacroix's painting are not only devoted to the understanding of various facets of the original; they are also a form of tribute to womanhood. It was indeed during this very period that a woman came into Picasso's life who brought him happiness and faith in life through her classic beauty and positive attitude towards life. This was Jacqueline Roque, whom he married in 1961. Just as Picasso had rediscovered the proud and noble bearing of Greek women in North Africa, so also the beauty of Jacqueline Roque was allied with the noble harmony of Delacroix's painting. And it seems no chance that some of his first portraits of Jacqueline show her in a costume that is close to those in Delacroix's paintings: the decoration and the refinement of the arabesques and tones conjure up an atmosphere that must continually have fascinated him while he was working on the series of variations on *Les Femmes d'Alger*. The series and the portraits of Jacqueline are thus linked in a reciprocal relationship, but only Picasso can know how this came about.

It is characteristic of Picasso's work from 1954 onwards that his paintings, drawings and engravings are arranged in series, connected the one with the other by cycles such as these—and this includes not only works derived from great masterpieces of the past, but also those concerned with nature showing fragments of reality. This is the character of the series of portraits of Sylvette, the girl with the pigtail, dating from 1954. In each of these Picasso adopts a different way of seeing his model, thus producing a series of variations. This too was the origin of the series of *ateliers*: views of Picasso's studio in the villa La Californie with its strange decorations that seem to be Moorish, where the centrepiece of the composition is often an unfinished painting. So while Picasso was working on the series of variations on Velasquez's *Las Meninas*, he was also painting a series of pictures whose subject was suggested by pigeons flying off the terrace of his villa. It seems almost as though he is taking up the thread of analytical Cubism again.

During the years 1907–13 he had become dissatisfied with the single viewpoint of traditional representation and had therefore taken to analysing and dissecting the objects he used as his subject-matter, showing various aspects of them and thus breaking down the unity of a whole form into a series of discontinuous parts. The same process characterises Picasso's present working method, except that is no longer the object but rather the artist's own way of seeing that is analysed and unravelled. Here, too, Picasso reveals himself as an extremely up-to-date artist—he has always shown himself able both to reflect and illuminate the spiritual currents of his day.

The period to which these cycles of works belong is interrupted only briefly in 1959 by a group of paintings, which used understandably to be known as the 'Spanish period', whose creation coincided with Picasso's

21. *The Painter and his Model*
1965, oil on canvas
Mattioli Collection, Milan

Pl. 43

45

move to the Château de Vauvenargues. His renewed contact with his Spanish friends may perhaps explain the severe and restrained style of these still-lifes and interiors, in which simple objects (such as a chest-of-drawers or a demi-john) regain new importance. But the rest of Picasso's work during this most recent decade has continued in the form of cycles. The variations on Delacroix's *Les Femmes d'Alger* were followed by the series around Velasquez's *Les Meninas*, then by another inspired by Manet's masterpiece *Le Déjeuner sur l'Herbe*. While Manet had deliberately removed the mythological content from his subject, Picasso restores it. A fourth series takes Poussin's *Rape of the Sabine Women* as its model. These are followed by series based on subjects that emerge from the fanciful transformation of reality in the form of images, such as the very extensive cycle of drawings and lithographs devoted to bull-fighting. The works of recent years, some of which could be seen at the great Picasso exhibition in Paris during the winter 1966–7 seem to provide a synthesis of the material tackled and of the creative process in the preceding cycles. Alongside a series of portraits of his wife, together with a large and handsome dog which Picasso had kept for a number of years, he also painted a series devoted to the theme of the artist and his model, which has yet to be seen *in toto* and which may yet produce many further variations. In describing this method of working by cycles we have made the analogy above with his analysis of objects that we see in his phase of analytical Cubism, and mentioned how subsequently the object of his analysis has become his own vision. The series *The Artist and his Model*, which constitutes a sort of self-examination and study of his working method, seemingly provides a synthesis and a summing-up of the results of that analysis. The artist is always faced with his model, with reality, a reality that does not consist solely of objective facts, but also includes his dreams and longings. He works continually not to represent this reality but to give it a shape in order to suggest it. This is the secret of the very latest works in which with a series of lines, an outline or a number of brushstrokes the canvas suddenly takes on the form of a woman's body—not painted, but rendered solely by the outline enclosing a white area of canvas—an evocation rather than a representation. The works of recent years seem indeed to owe their existence to a sort of magic, as if they were a mirage, and yet they are materially present and a justification of what Picasso said lately in an interview: 'Painting is forever supreme'. However much he might be be striving to achieve a conclusion, the variety inherent in the continual contrast in the subject-matter of his latest canvases always provides something new, surprising and unpredictable. It is for this reason that Picasso at 88 is still one of the 'young painters', an artist who has avoided being identified as a historical monument through continual change and renewal. His work which covers the vast span of nearly seventy years, is far from having reached a final point of development.

Pl. 44
Fig. 21

**Life above art**

The variety, many-sidedness and polyphony of Picasso's work are the very essence of his art, and characterise him as a man of his century. Certainly no one can doubt Picasso's mastery—it is evident from his very first drawings. But many are put off and confused by the multiplicity of his expression, by the contradictions between individual works, and by his seemingly kaleidoscopic variety of styles and forms. But the viewer who does not see that the portraits drawn with such precision at about the time of the first World War, the monstrous distortions of the phase which owes its name to their character, the Cubist still-lifes and the Dionysian inebriation of the paintings around 1955 and from the years following the second World War, can all come from the creative genius of a single artistic personality, does not understand the essence and meaning of Picasso's stature.

For this variety and many-sidedness is the key to Picasso's genius, (akin to that which Baudelaire attributed to Delacroix with the words: 'de quelle spécialité la Providence avait chargé Eugène Delacroix dans le développement historique de la peinture') and it is a direct consequence of this diversity

46

that Picasso has been able to maintain his spontaneity and originality right into old age. He has never allowed his art to become fossilised. For him any working method that would have restricted his creativity to a self-sufficient and complete formula has always seemed false in relation to life. For this reason he has resisted any temptation to carry his work to a definitive conclusion – the series which he has painted in recent years is evidence still of his mental flexibility as much as of his refusal to establish firm points of reference. 'Previously', he once said, 'paintings approached their completion step by step. The picture was the result of a building up. For me a picture is the result of destruction. I create a painting and then I destroy it. But when I make the summing-up at the end, nothing has been lost'. He continually sought to avoid a 'finished' appearance since he counted life above art, and life cannot be contained in a formula or style; it remains fluid, ambiguous and enigmatic. He could have 'specialised' in the rendering of the melancholy that characterised the Blue period, and he would have still remained a great master; he would enjoy an important place in history simply as the creator and exponent of Cubism, but this was not what he wanted. With his unlimited faith in the vitality of life he refused to tolerate any bounding of it by rules, styles or formulae. He trusts only direct and sincere expression. His artistic convictions are still essentially those of an anarchist, the anarchist of the Bohemian group from the café *El Quatre Gats* in Barcelona. But more than that, he had the courage to pursue sincerity instead of facile perfection, and this courage also gave him – apart from a previously undreamt of freedom – the possibility of making discoveries without even pursuing them. His unconcerned attitude towards nature as well as art enabled him to notice things that others do not see, not only because he is sharper than most, but because he has not lost the gift of surprise and because he will not tolerate habits and will not accept the easiest and most obvious interpretations of the things he sees.

Picasso's work cannot be seen in the sense of an autobiography, even though some sizeable parts of it may have light cast upon them by events in his own life. He is far from being shut away in an ivory tower, using his works solely as the vehicles for his own feelings. From the very beginning he succeeded in transcending the limits of his own world: the form which he gives to his own experiences always seeks to be the expression of something more universally meaningful. What cannot be seen as an autobiography can, however, be seen as a synthesis of a whole age. So there is no withdrawal when Picasso feels the need to set against the concept of the classic ideal of beauty – which he could perfectly accomplish – its opposite, that of a diabolical, extravagant ugliness. His creativity extends not only to form, style and content, but also to the sphere of the myth through which he has endowed the beautiful and the ugly, despair and joy, with mythical force. Having allowed himself unhesitatingly to be carried along in the tide of life, he has gained a deeper understanding of it, with all its contradictions.

All this has gained him the reputation of being a personality of great internal diversity, a wandering soul. His repeated self-renewal – instead of following a continual development – has often been regarded as a sign of flippancy and inconstancy, while it is in fact quite the opposite – Picasso has always remained faithful to himself. It may be that he has been a wandering soul, but only in the same sense as that of his compatriot, Don Quixote de la Mancia, who preferred the uncertain life of adventure to being hemmed in by rules, set patterns and predetermined forms. In this respect Picasso, who has been a Parisian for over half a century, has remained a Spaniard, pursuing the adventurous path of sincerity and originality and shaping his experience into new images that have the faculty of continually taking us by surprise. He has seen, and reveals to us, things which appear to be miracles. He has been able to extend his vision to the creation of meaningful forms that symbolise our whole age, and which for that reason – like *Guernica* – appear almost like prophecies written on the wall; and this was precisely Pablo Picasso's intention.

**Colour plates**

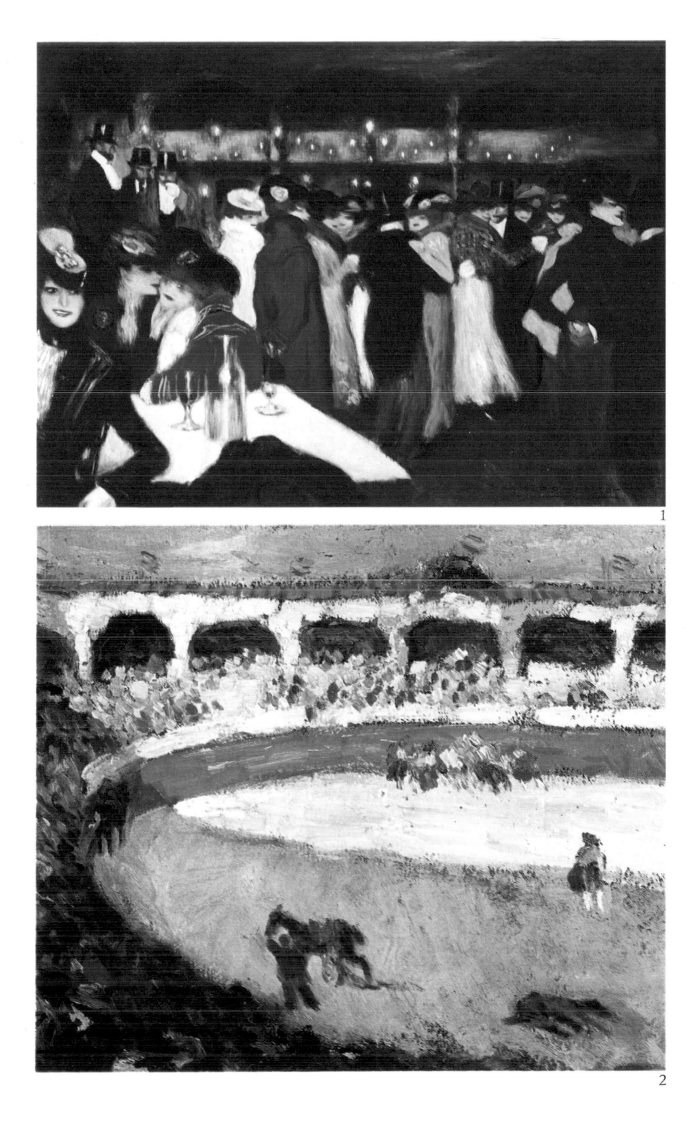

1

2

3

4

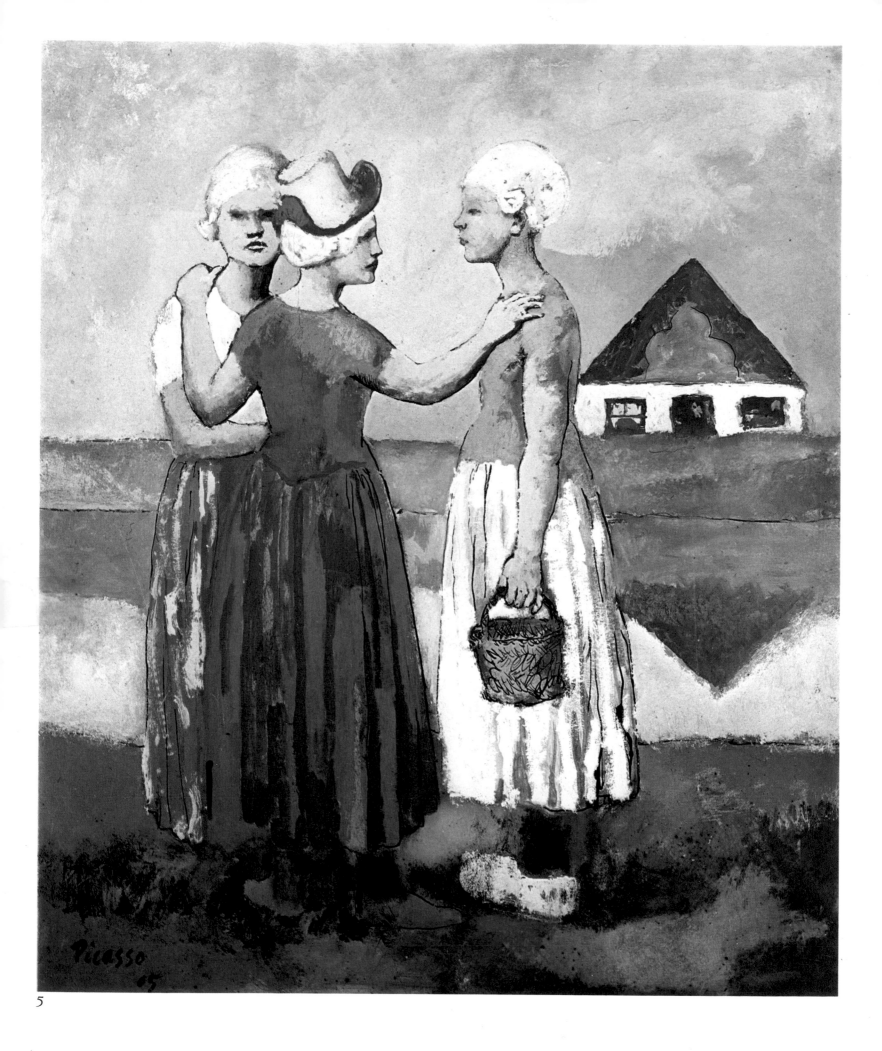

5

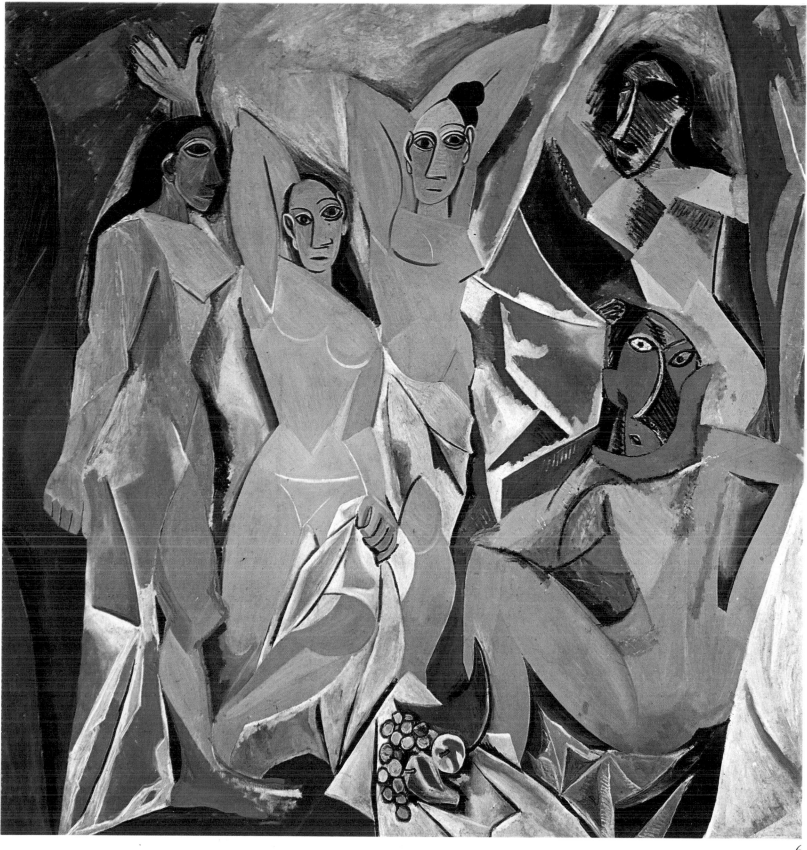

7

8

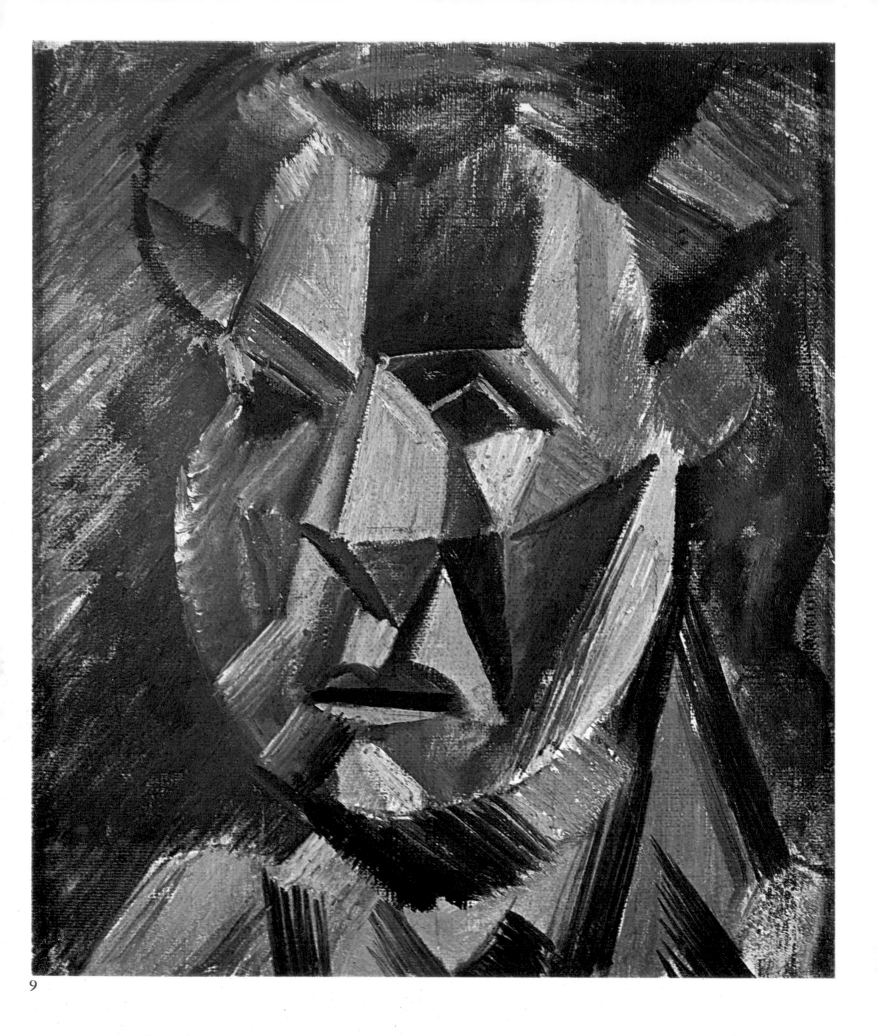

9

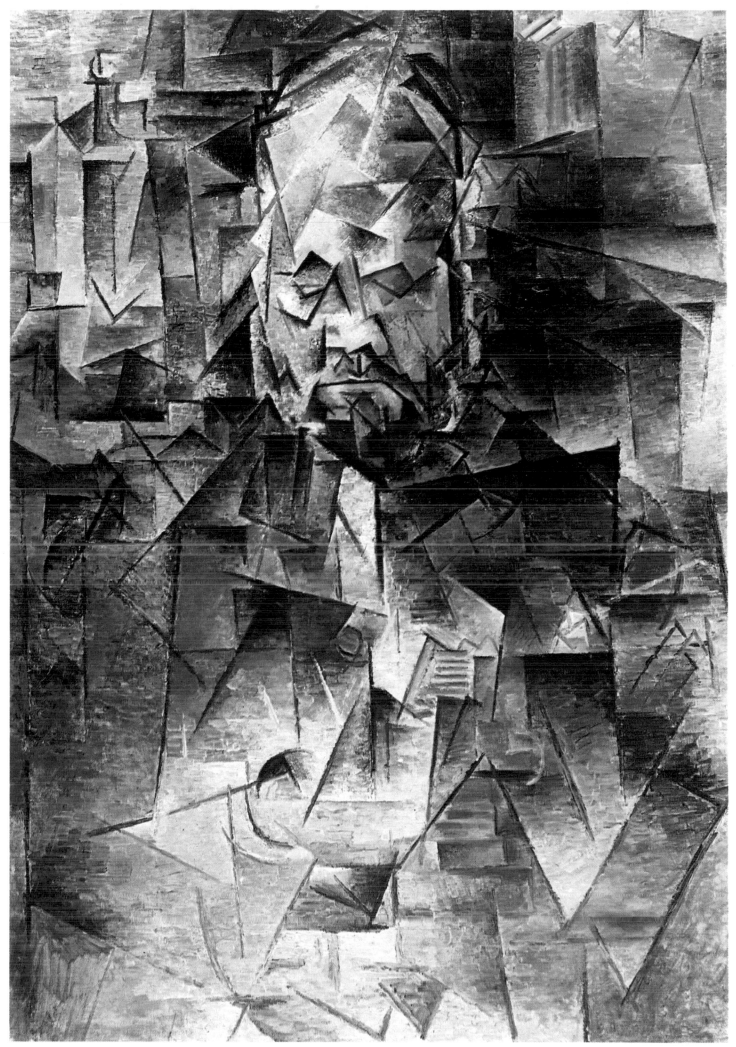

10

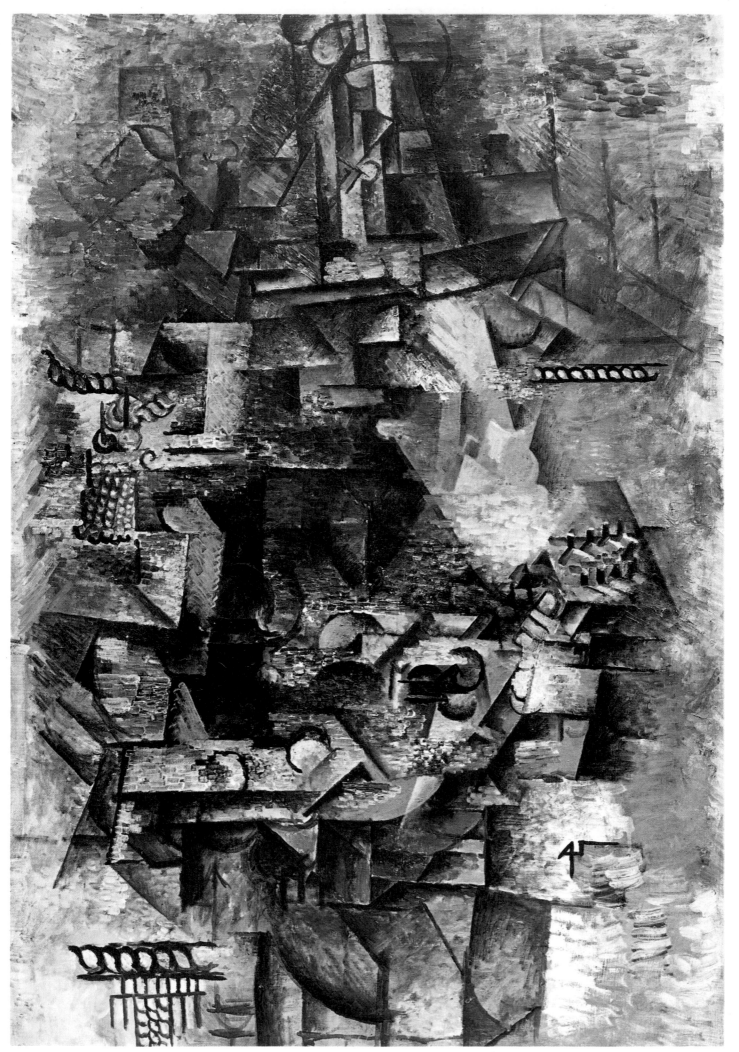

11

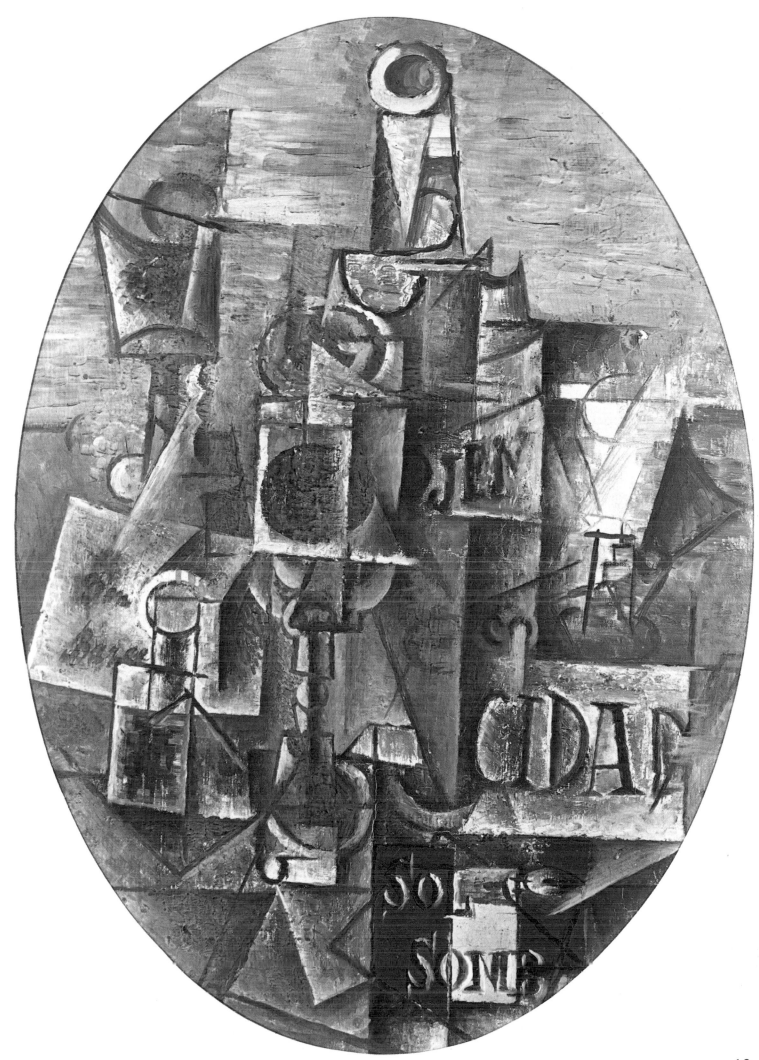

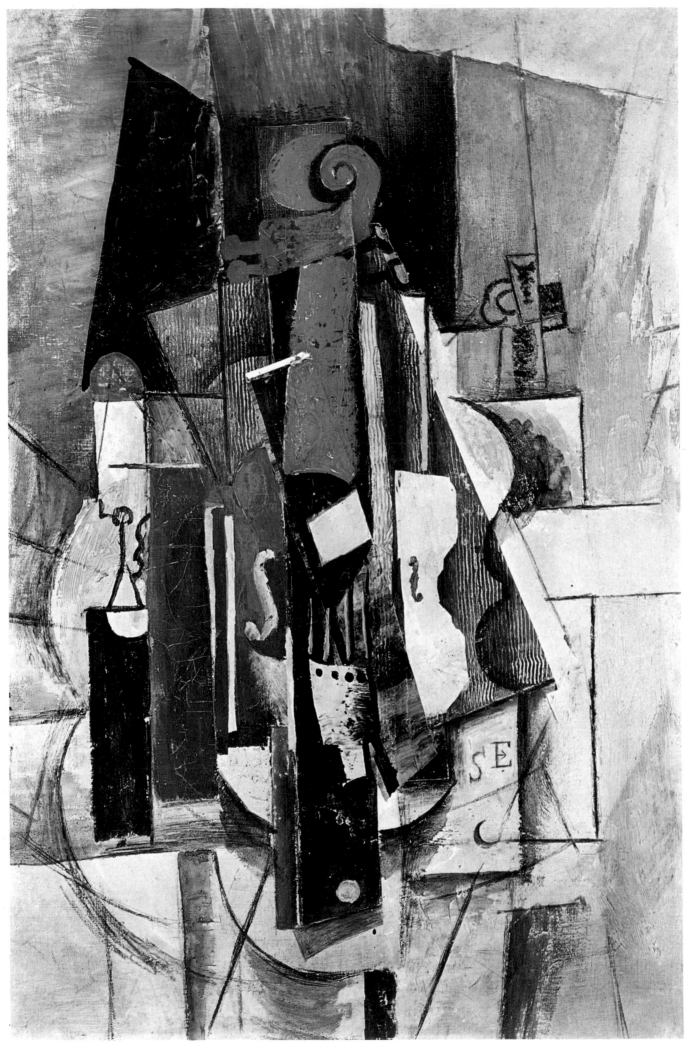

13

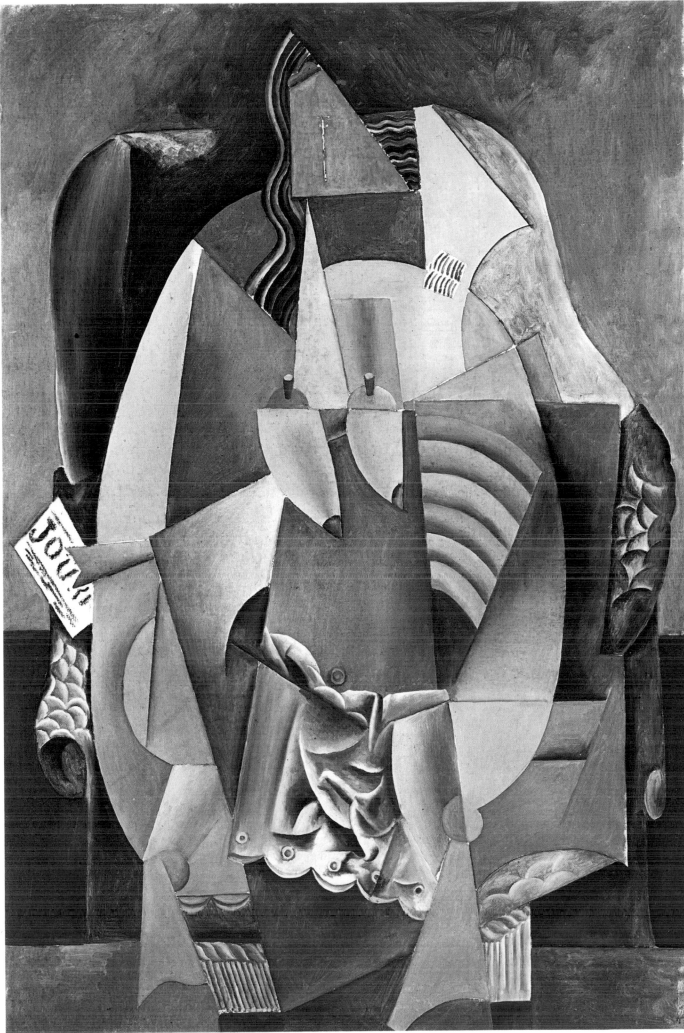

14

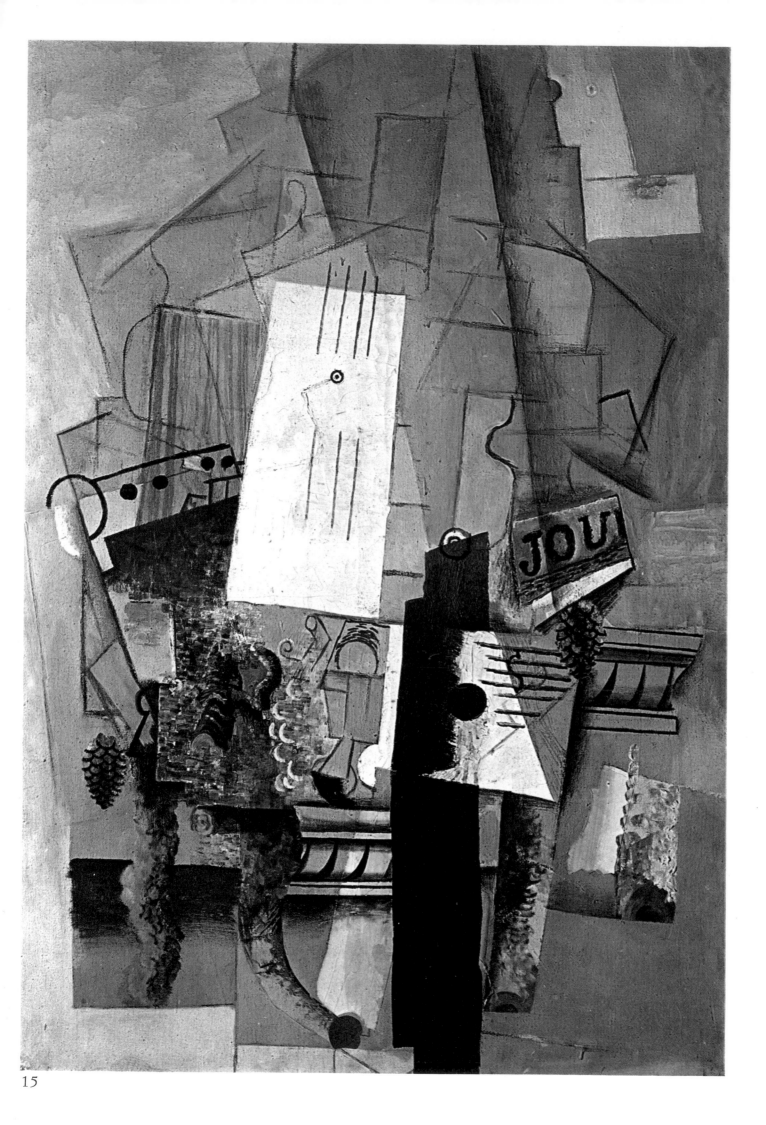

15

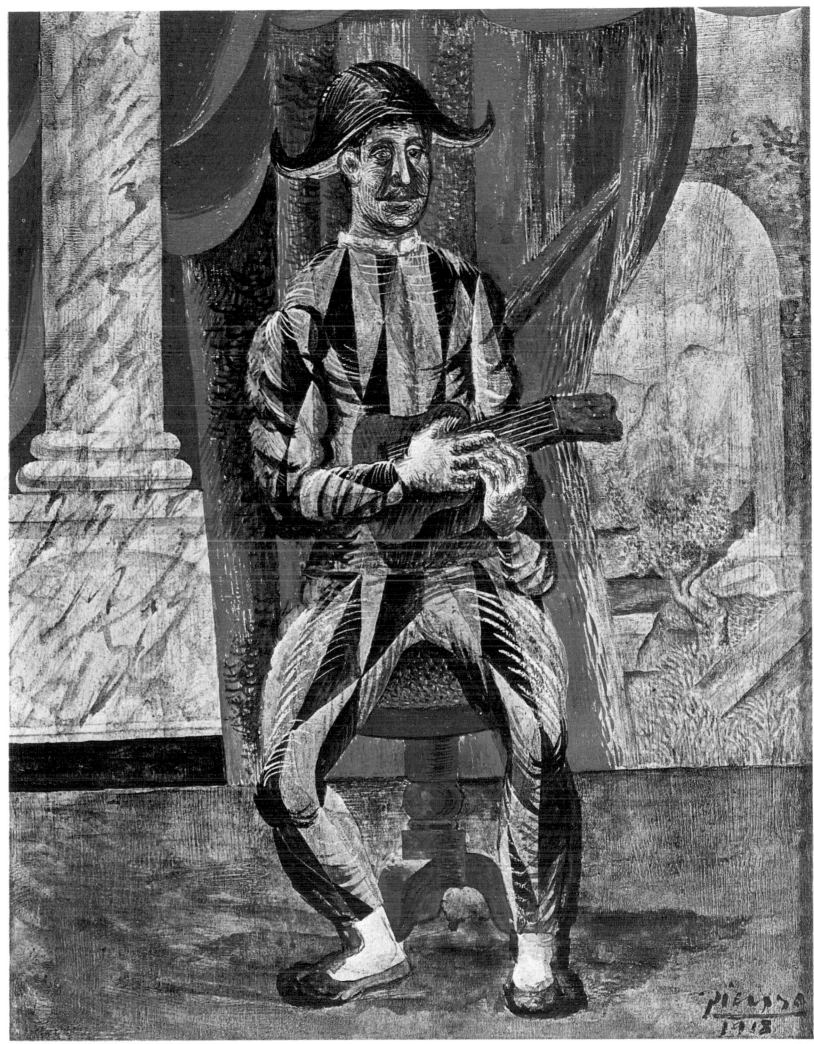

16

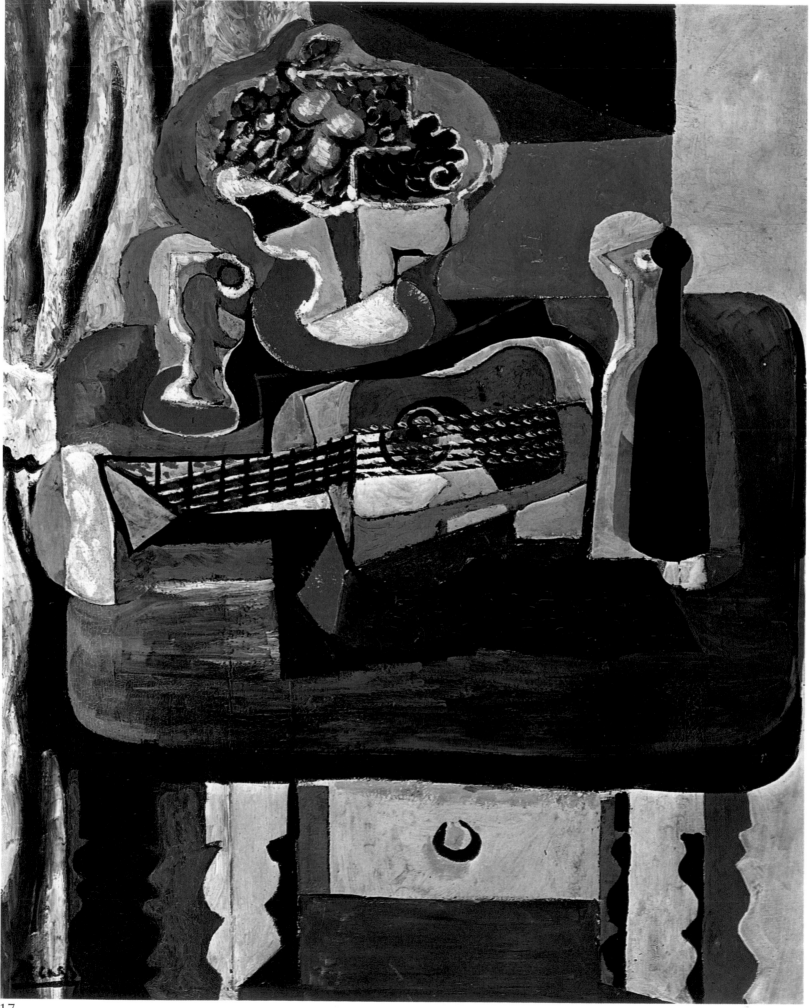

17

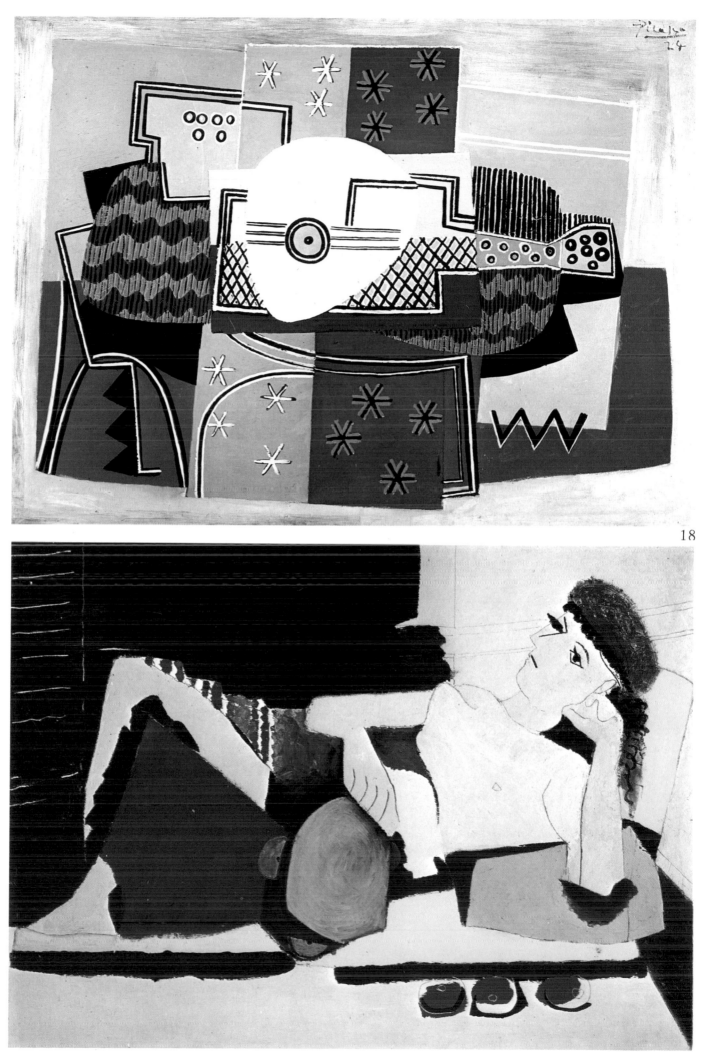

18

19

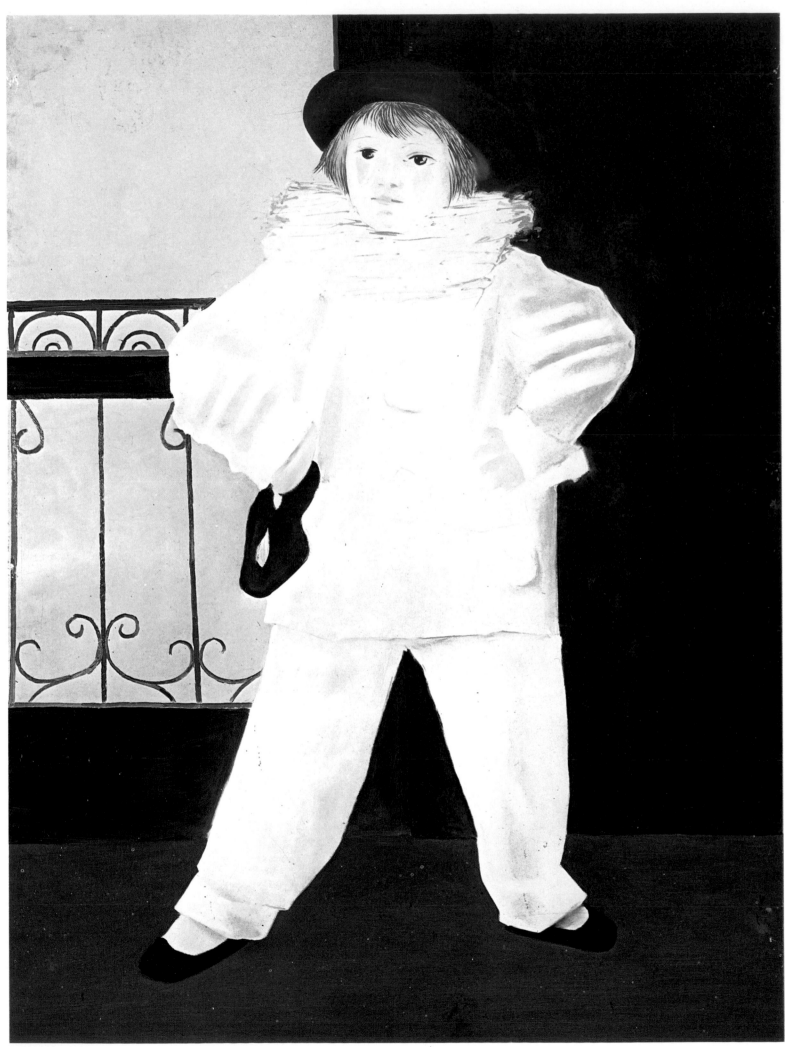

21

24

25

27

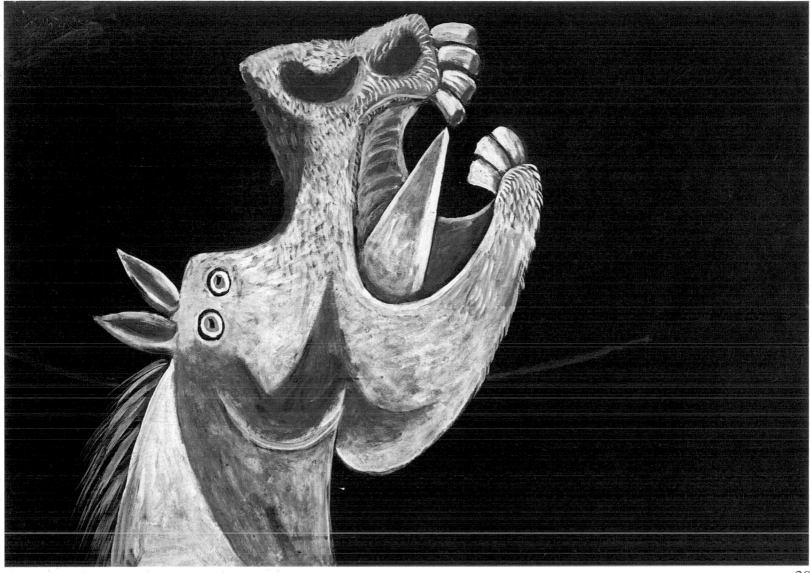

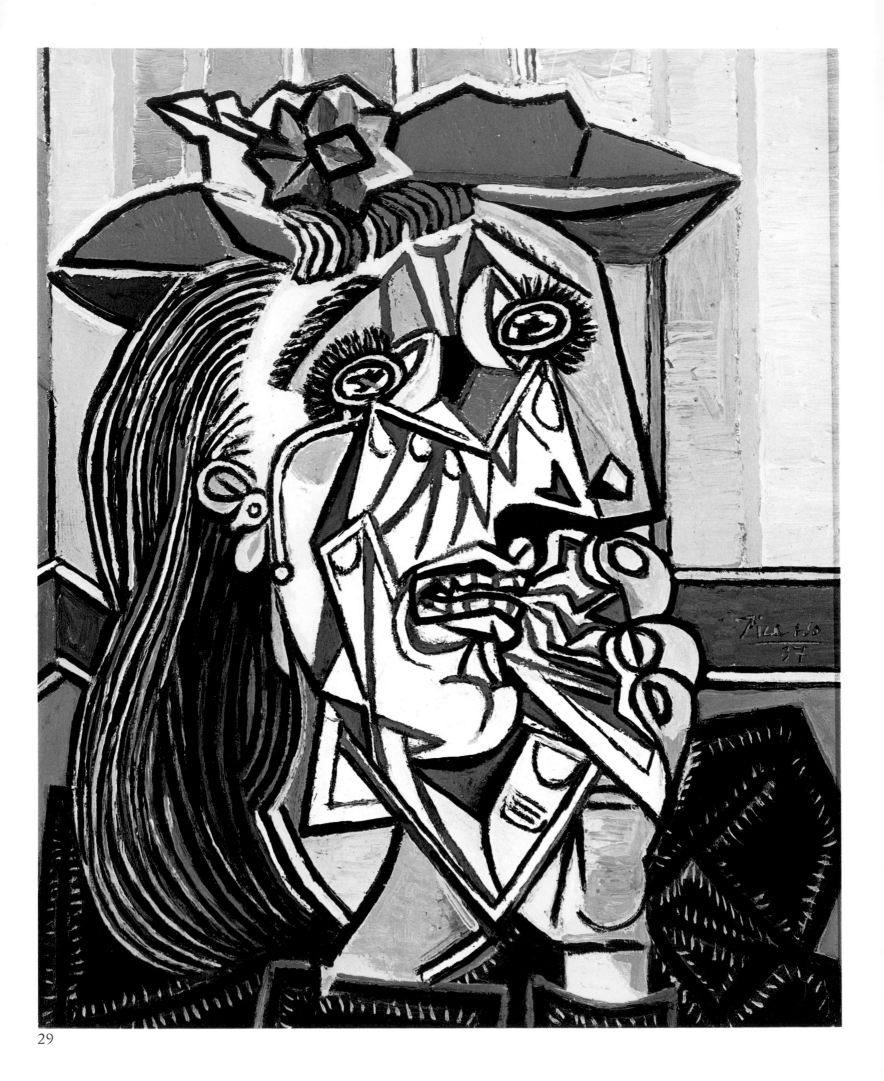

29

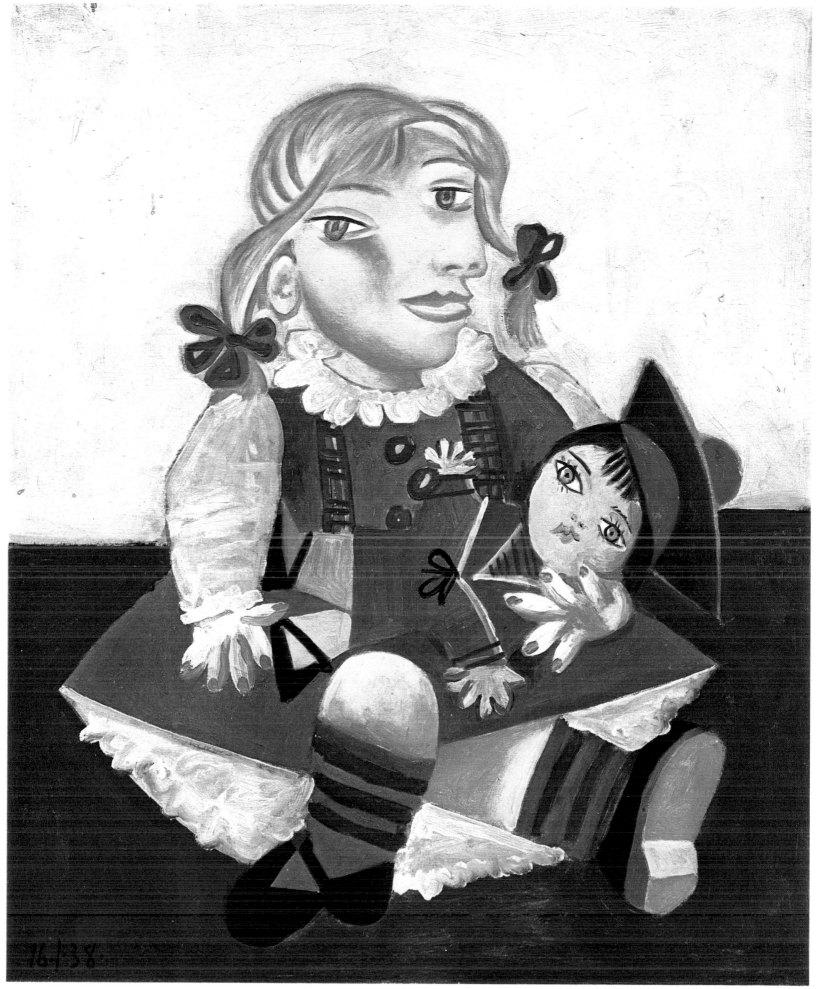

16-1-38

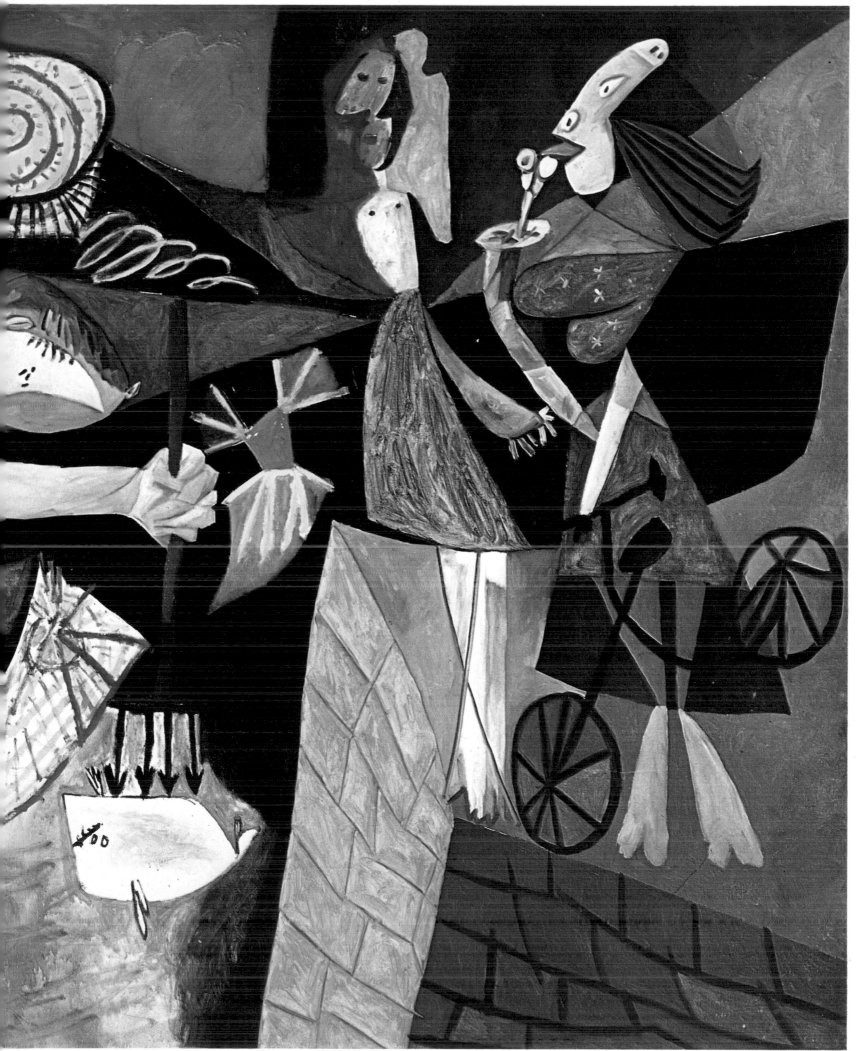

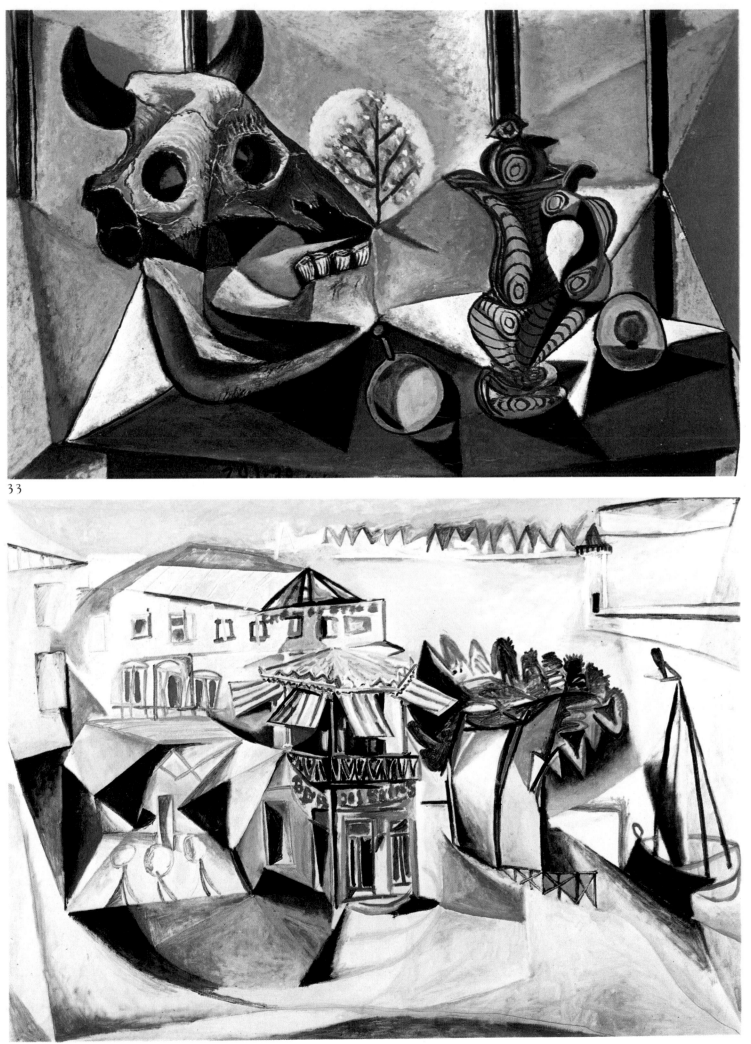

33

34

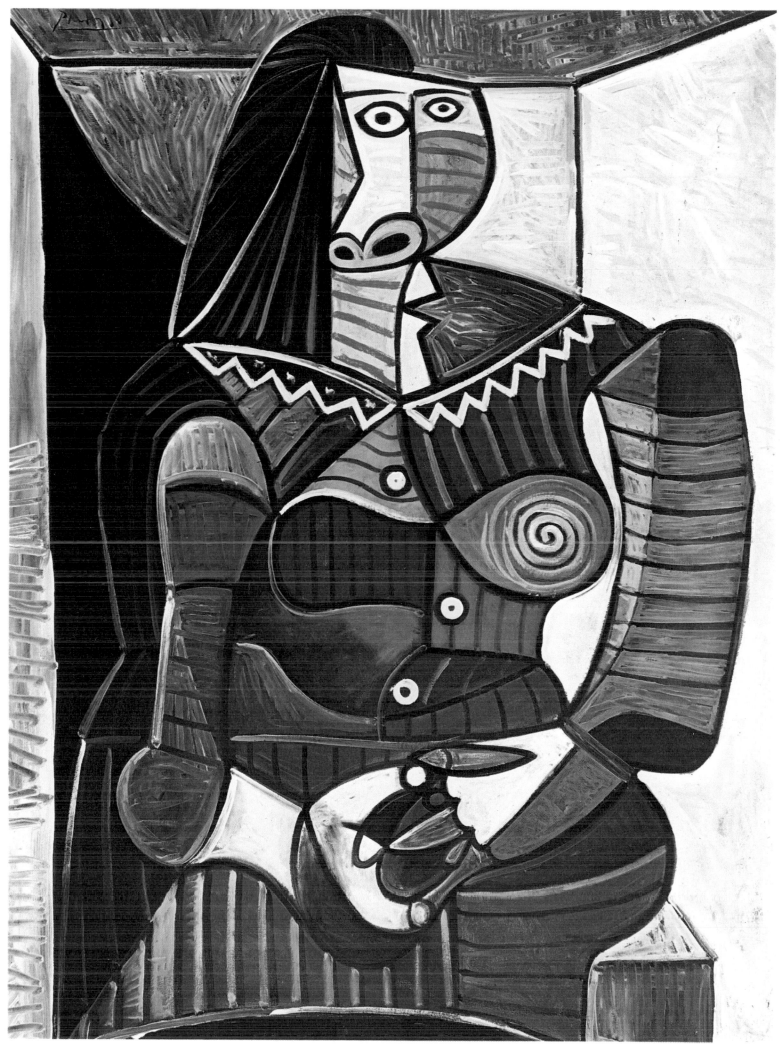

35

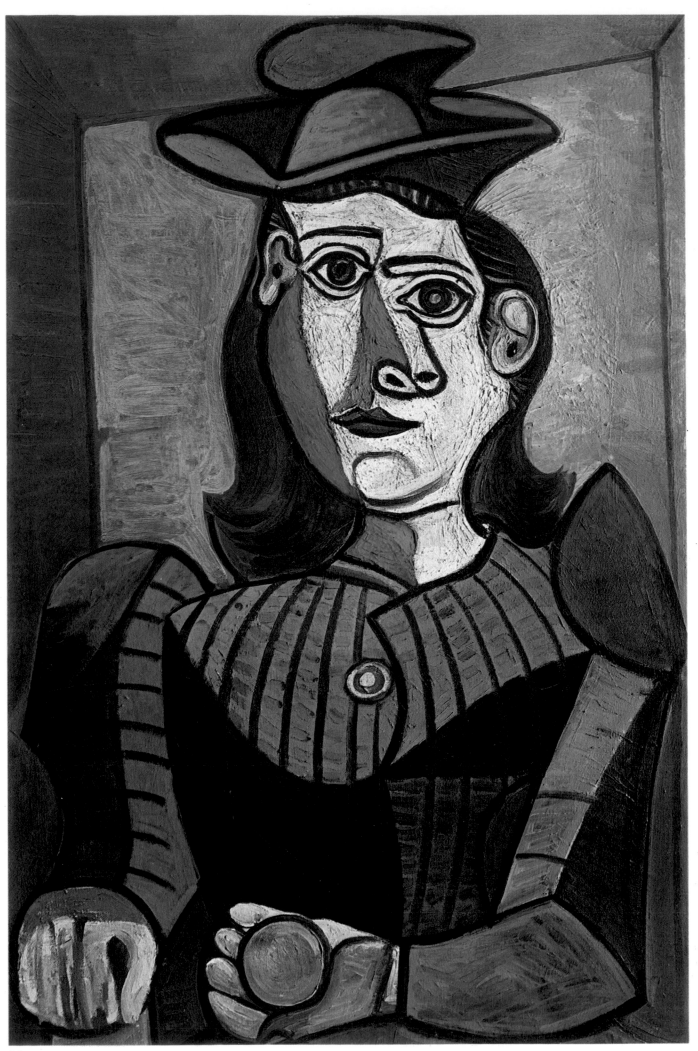

36

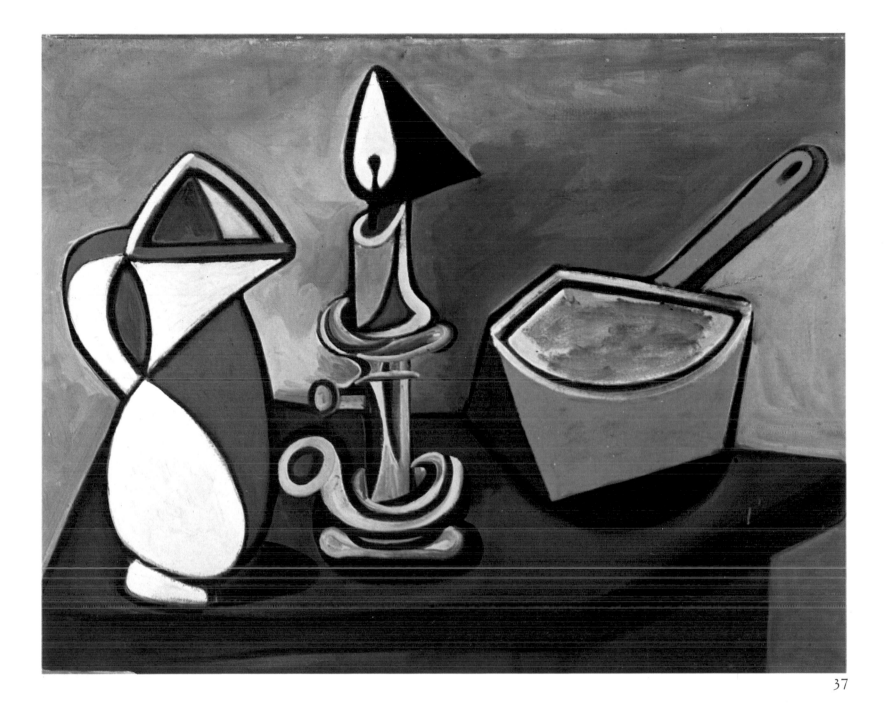

38

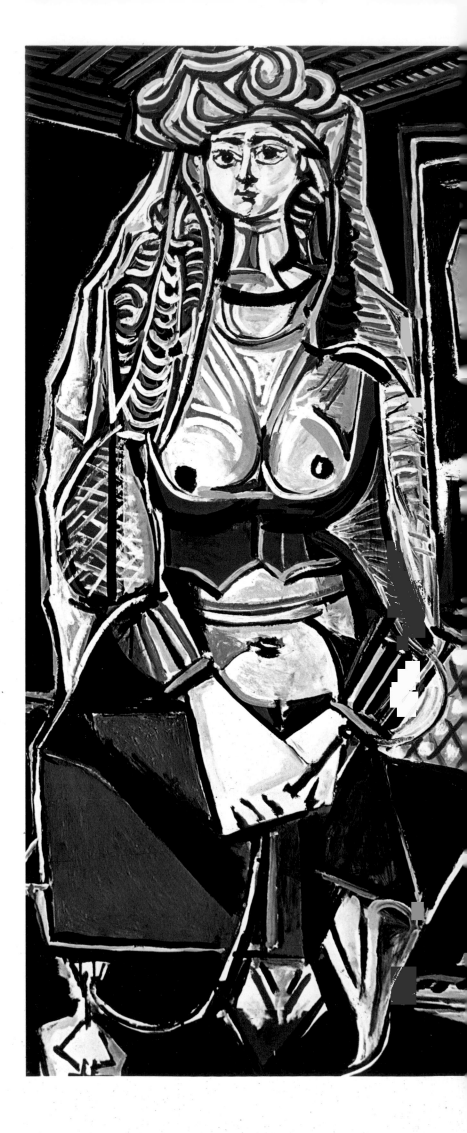

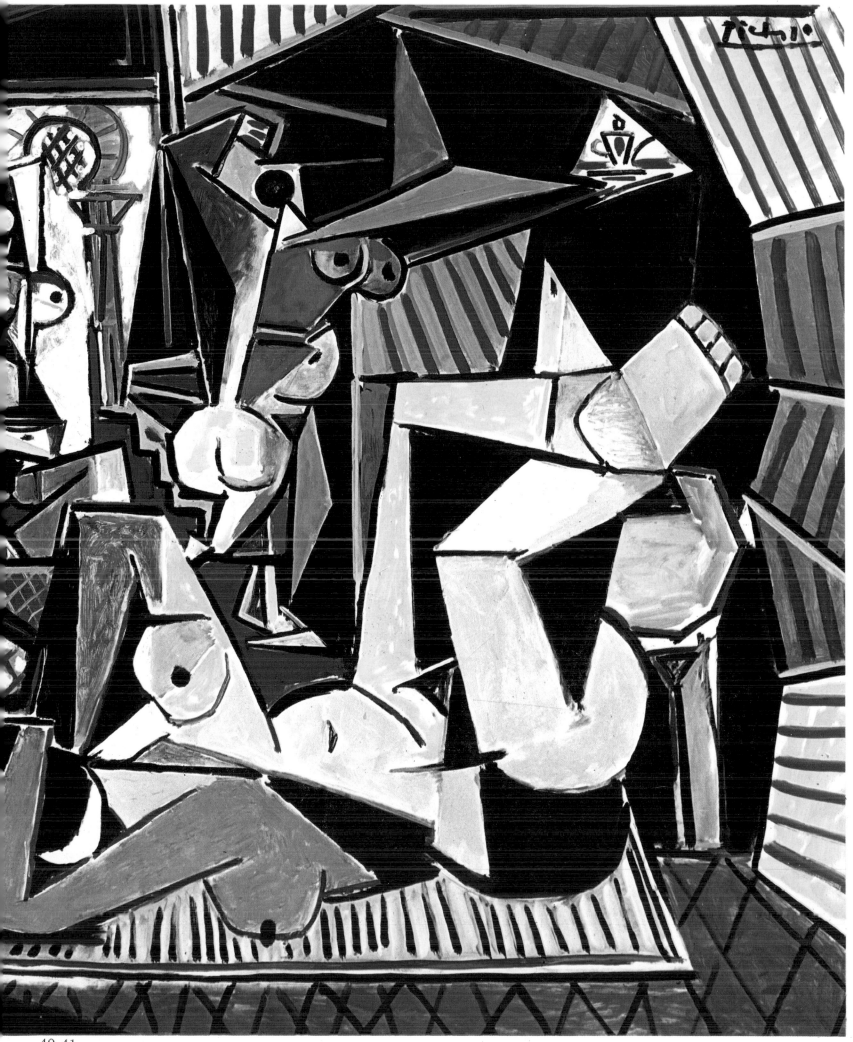

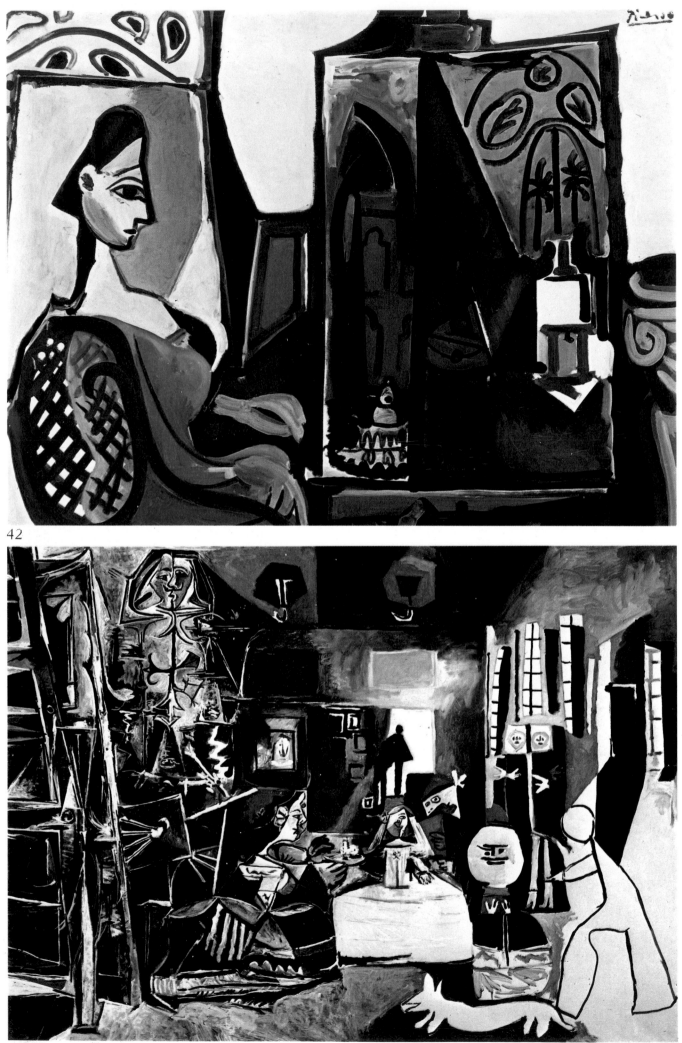

42

43

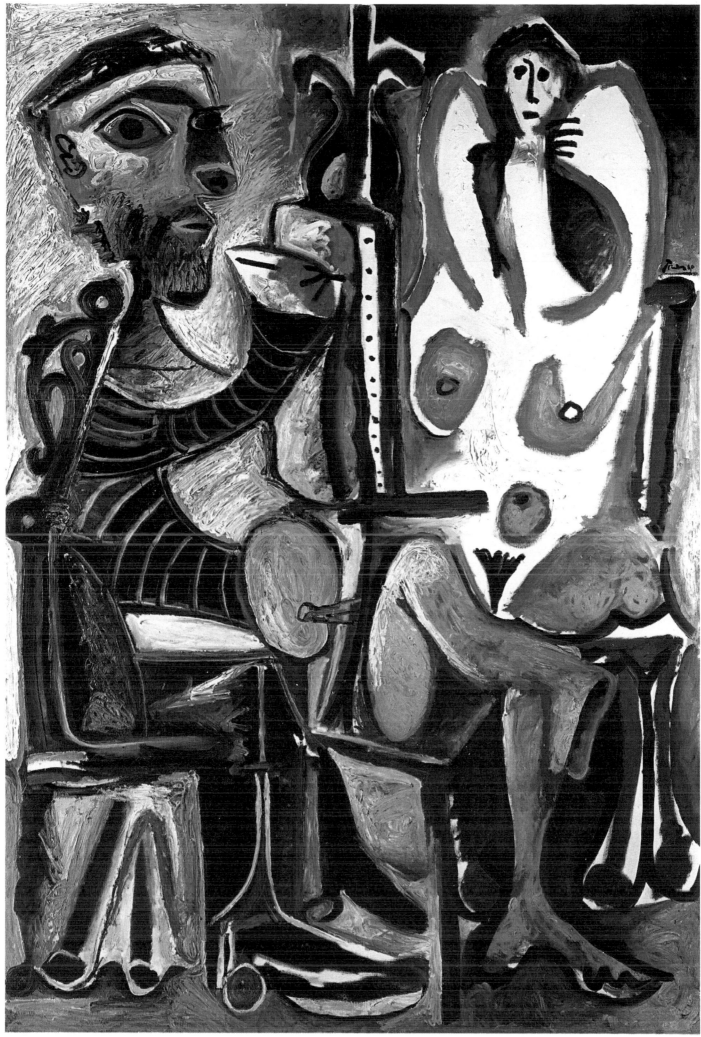

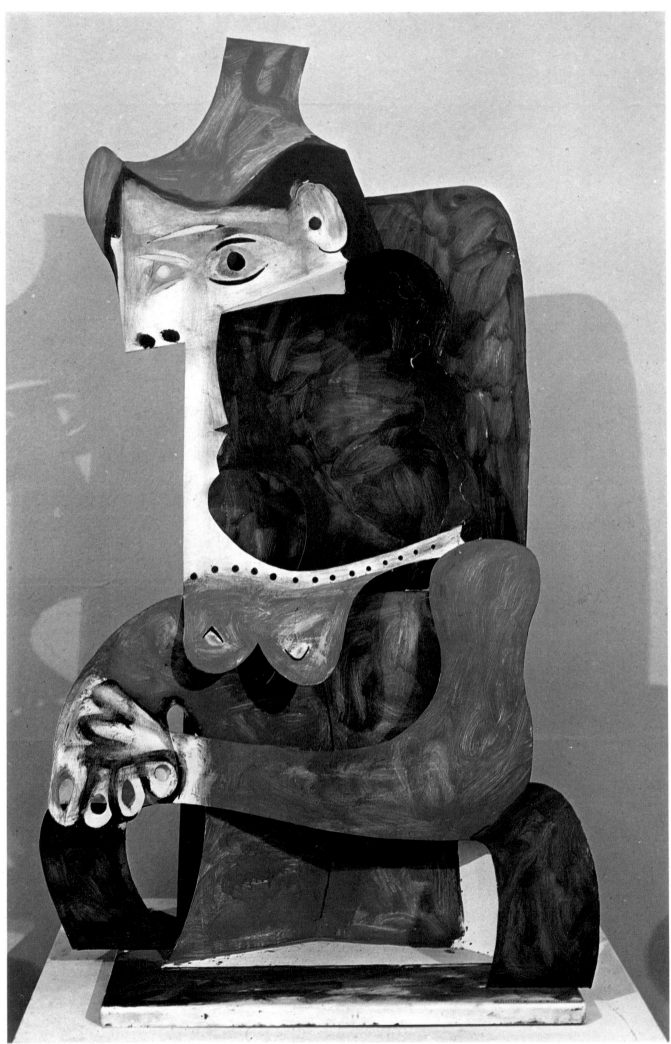

# Description of colour plates

1. *Le Moulin de la Galette*
1900, oil on canvas, $35\frac{3}{8} \times 45\frac{5}{8}$ in ($90 \times 116$ cm)
Justin K. Tannhauser Collection, New York

2. *Bull-fight*
1901, oil on canvas, $18\frac{1}{2} \times 22$ in ($47 \times 56$ cm)
Private Collection

3. *Woman in Blue*
1901, oil on canvas, $52\frac{1}{2} \times 39\frac{3}{4}$ in ($133\cdot5 \times 101$ cm)
Museo Nacional de Arte Moderno, Madrid

4. *Portrait of Sabartès*
1901, oil on canvas, $32\frac{1}{4} \times 26$ in ($82 \times 66$ cm)
Pushkin Museum, Moscow

5. *The Three Dutch Women*
1905, gouache, $29\frac{7}{8} \times 26$ in ($76 \times 66$ cm)
Musée National d'Art Moderne, Paris

6. *Les Demoiselles d'Avignon*
1907, oil on canvas, $96 \times 91\frac{3}{4}$ in ($244 \times 233$ cm)
Museum of Modern Art, New York

7. *Nude with Drapery*
1907, oil on canvas, $59\frac{7}{8} \times 39\frac{3}{4}$ in ($152 \times 101$ cm)
Hermitage, Leningrad

8. *Fruit-dish with Pears*
1909, oil on canvas, $36\frac{1}{4} \times 28\frac{3}{4}$ in ($92 \times 73$ cm)
Hermitage, Leningrad

9. *Head of a Woman*
1909, oil on canvas
Museum of 20th-Century Art, Berlin

10. *Portrait of Ambroise Vollard*
1909–10, oil on canvas, $36\frac{1}{4} \times 25\frac{5}{8}$ in ($92 \times 65$ cm)
Pushkin Museum, Moscow

11. *Mandolin Player*
1911, oil on canvas, $38\frac{5}{8} \times 27\frac{1}{2}$ in ($97 \times 70$ cm)
M. F. Graindorge Collection, Liège

12. *Spanish Still-life*
1912, oil on canvas, oval, $18\frac{1}{8} \times 13$ in ($46 \times 33$ cm)
Private Collection

13. *The Violin*
1913, oil on canvas, $317 \times 21\frac{1}{4}$ in ($81 \times 54$ cm)
Siegfried Rosengart Collection, Lucerne

14. *Woman in an Armchair*
1913, oil on canvas, $31\frac{7}{8} \times 21\frac{1}{4}$ in ($81 \times 54$ cm)
Ingeborg Pudelko Collection, Florence

15. *Le Gueridon*
1914, oil on canvas
Kunstmuseum, Basle

16. *Harlequin with a Guitar*
1918, tempera on panel, $13\frac{3}{4} \times 10\frac{5}{8}$ in ($35 \times 27$ cm)
M. H. Berggruen Collection, Paris

17. *Glass, Flowers, Guitar and Bottle*
1919, oil on canvas, $39\frac{3}{8} \times 31\frac{7}{8}$ in ($100 \times 81$ cm)
M. H. Berggruen Collection, Paris

18. *Still-life with a Guitar*
1924, oil on canvas, $38\frac{3}{8} \times 51\frac{1}{8}$ in ($97\cdot5 \times 130$ cm)
Stedelijk Museum, Amsterdam

19. *Woman with a Tambourine*
1925, oil on canvas, $38\frac{1}{4} \times 51\frac{1}{8}$ in ($97 \times 130$ cm)
Musée de L'Orangerie, Paris

20. *Portrait of Paul as a Pierrot*
1924, oil on canvas, $51\frac{1}{8} \times 37\frac{3}{4}$ in ($130 \times 96$ cm)
Owned by the artist

21. *Studio*
1928, oil on canvas
Peggy Guggenheim Collection, Venice

22–3. *Fashion Studio*
1926, oil on canvas, $67\frac{3}{4} \times 100\frac{3}{4}$ in ($172 \times 256$ cm)
Musée National d'Art Moderne, Paris

24. *Still-life (Pichet, bol et fruit)*
1931, oil on canvas, $51\frac{1}{8} \times 64$ in ($130 \times 162\cdot5$ cm)
Private Collection

25. *Women and Children by the Sea*
1932, oil on canvas, $31\frac{7}{8} \times 39\frac{3}{8}$ in ($81 \times 100$ cm)
Michael Hertz Collection, Bremen

26. *Seated Woman with a Book*
1937, oil and pastel on canvas, $51\frac{1}{8} \times 38\frac{1}{4}$ in ($130 \times 97$ cm)
Private Collection

27. *Portrait of Dora Maar*
1937, oil and pastel on canvas, $21\frac{5}{8} \times 18\frac{1}{8}$ in ($55 \times 46$ cm)
Owned by the artist

28. *Head of a Horse*
(study for the central figure of *Guernica*)
1937, oil on canvas, $25\frac{5}{8} \times 36\frac{1}{4}$ in ($65 \times 92$ cm)
Museum of Modern Art, New York

29. *Weeping Woman*
1937, oil on canvas, $23\frac{5}{8} \times 19\frac{1}{4}$ in ($60 \times 49$ cm)
Antony Penrose Collection, London

30. *Portrait of Maia with a Doll*
1938, oil on canvas, $28\frac{3}{4} \times 23\frac{5}{8}$ in ($73 \times 60$ cm)
Owned by the artist

31–2. *Night Fishing at Antibes*
1939, oil on canvas, $81\frac{1}{8} \times 135\frac{7}{8}$ in ($206 \times 345$ cm)
Museum of Modern Art, New York

33. *Still-life with Flowers, a Jug and Ox's Skull*
1939, oil on canvas, $31\frac{1}{2} \times 39\frac{3}{8}$ in ($80 \times 100$ cm)
Staatgalerie, Munich

34. *Café at Royan*
1940, oil on canvas
Private Collection

35. *Woman in Green*
1943, oil on canvas, $51 \times 38$ in ($129\cdot5 \times 96\cdot5$ cm)
Ciannait Sweeney Collection, New York

36. *Woman with a Blue Hat*
1944, oil on canvas, $36\frac{1}{4} \times 23\frac{5}{8}$ in ($92 \times 60$ cm)
Owned by the artist

37. *The Enamel Saucepan*
1945, oil on canvas, $32\frac{1}{4} \times 63$ in ($82 \times 160$ cm)
Musée National d'Art Moderne, Paris

38. *Woman in an Armchair*
1949, oil on canvas, $39\frac{3}{8} \times 31\frac{7}{8}$ in ($100 \times 81$ cm)
Private Collection

*continued overleaf*

39. *Two Children*
1952, oil on canvas, 36¼ × 28¾ in (92 × 73 cm)
Owned by the artist

40–1. *Les Femmes d' Alger*
1955, oil on canvas, 44⅞ × 57½ in (114 × 146 cm)
Victor W. Ganz Collection, New York

42. *The Studio*
1956, oil on canvas, 44⅞ × 57½ in (114 × 146 cm)
Rosengart Gallery, Lucerne

43. *Las Meninas*
(after Velasquez), 1957, oil on canvas, 6 ft 4¾ in × 8 ft 6⅜ in
(1·94 × 2·6 m)
Private Collection

44. *The Painter and His Model*
1963, oil on canvas, 76⅞ × 51⅛ in (195 × 130 cm)
M. H. Berggruen Collection, Paris

45. *Woman with a Hat*
1963, sheet steel, bent and painted
Private Collection

## Biographical outline

1881. Birth of Pablo Picasso on 25th October, at Malaga in Andalusia. His father, José Ruiz Blasco, taught drawing at the School of Arts and Crafts, and was Curator of the Museum at Malaga. His mother, from whom Pablo was to take his surname, was Maria Picasso Lopez.
1884. Pablo's sister Lola is born in Malaga.
1887. Pablo's second sister, Conchita, is born in Malaga.
1891. In September the family move to La Coruña in Galizia, where the father takes over the chair of drawing at the Da Guarda school. Conchita dies. José Ruiz Blasco, recognising his son's extraordinary talent for painting, gives him his materials and gives up painting.
1895. In September the family moves to Barcelona, following the election of José Ruiz Blasco to a professorship at La Lonja Academy of Fine Art. Pablo enrolls himself at the same Academy after having passed the very difficult entrance examination with distinction.
1897. After a summer spent at Malaga, Pablo enrolls himself in September for courses at the Royal Academy of San Fernando in Madrid, although he does not attend them.
1899. Frequents the *El Quatre Gats* café, the rendez-vous of the avant-garde in Barcelona.
1900. Travels to Paris with his friend Casegemas and stays there until the end of December.
1901. Founds the review *Arte Joven* in Madrid with Francisco de Asìs Soler. Second journey to Paris, with Jaime André Bonsons. Meets Max Jacob. Returns to Barcelona at the end of the year. Beginning of the Blue Period.
1902. Third journey to Paris, in October, together with Sebastian Júnyer.
1903. Returns to Barcelona from Paris at the end of the year.
1904. Fourth journey to Paris, in April. Establishes himself in the studio of Paco Durio, in the Bateau-Lavoir.
1905. Meets Guillaume Apollinaire and gains the friendship of the American authoress Gertrude Stein and her brother Leo. Marries Fernande Olivier. Beginning of the Pink Period.

22. Pablo Picasso 1948

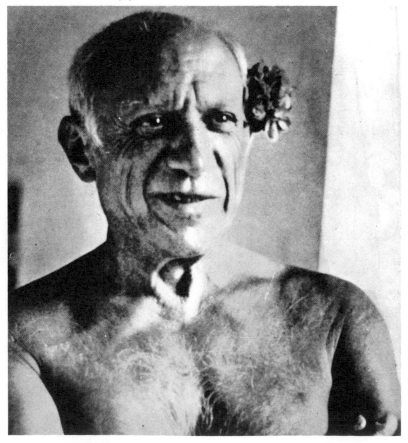

1906. Meets Henri Matisse through Gertrude and Leo Stein. Begins work on *Les Demoiselles d'Avignon*.

1907. Continues and completes *Les Demoiselles d'Avignon*. Meets the art-dealer D. H. Kahnweiler and Georges Braque.

1908. Gives a now-famous banquet in his studio in honour of Douanier Rousseau. Beginning of Analytical Cubism.

1909. Moves to 11, Boulevard Clichy.

1910. Meets Juan Gris and Louis Marcoussis. Exhibition in New York.

1912. Leaves Fernande Olivier and marries Marcelle Hubert (Eve). Moves from the Boulevard Clichy to 242, Boulevard Raspail. Meets Jacques Villon, Marcel Duchamp, Gleizes, Metzinger, Delaunay, Léger.

1913. Moves from Boulevard Raspail to 5, Rue Schoelcher. Death of his father, José Ruiz Blasco.

1916. Death of Marcelle Hubert. Picasso moves to Montrouge, 22, rue Victor Hugo.

1917. In February he travels to Rome with Jean Cocteau to work on the ballet *Parade*, with music by Satie and directed by Serge Diaghilev. Falls in love with the ballerina Olga Koklova and follows the ballet to Madrid and Barcelona.

1918. Marries Olga Koklova. Takes lodging at 23, rue la Boétie.

1919. Accompanies the Russian Ballet to London to do the stage design of *Le tricorne*. Meets Joan Miró. Guillaume Apollinaire dies as the result of a war wound.

1921. Birth of his son Paul.

1924. Works on the stage design of the ballet *Mercure*, with music by Satie and choreography by Massine. At Cap d'Antibes he meets André Breton, who has just published the *Surrealist Manifesto*.

1928. Devotes himself energetically to sculpture, creating a series of works in iron wire.

1930. Buys the Château de Boisgeloup, near Gisors.

1932. Big retrospective exhibition at the Georges Petit Gallery in Paris and at the Kunsthaus in Zürich. Meets Marie-Thérèse Walter who is to become his new companion.

1934. Goes on a long journey to Spain with Marie-Thérèse Walter. Separates from his wife Olga Koklova.

1935. Marie-Thérèse Walter gives birth to his daughter Maia. Engraves *Minotauromachia*.

1936. The Spanish Civil War breaks out in July. The Republican government names Picasso as the Director of the Prado Museum.

1937. Between the 8th and 9th January he writes the invective *Sueño y mentira de Franco*. On the 28th April, the little town of Guernica is bombed by Nazi aeroplanes. He paints the great panel *Guernica* which he exhibits in June at the Spanish Pavilion at the Universal Exhibition in Paris. Brief journey to Switzerland, meets Paul Klee.

24. Pablo Picasso

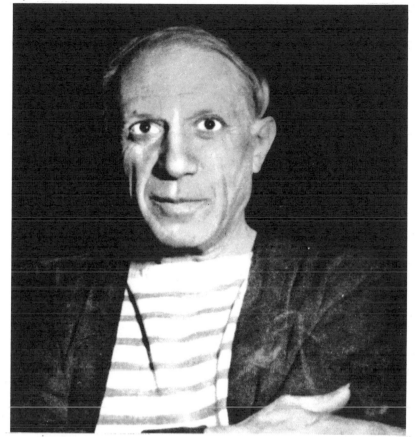

23. Picasso at Vallauris

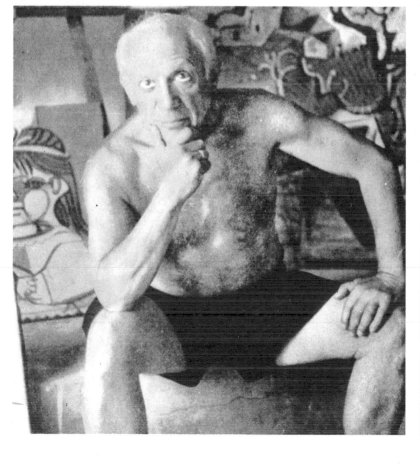

25. Picasso with his son Claude and Jean Cocteau the French playwright and impresario, at a bull-fight

1939. Great retrospective exhibition at the Museum of Modern Art in New York. His mother, Maria Picasso Lopez, dies in Barcelona.

1940. Returns in September to Paris, where he stays until the end of the war.

1941. Writes *Le désir attrapé par la queue*, a lyrical-grotesque comedy that is performed in Leiris's house by his friends who became actors for the occasion: Camus, Sartre, Simone de Beauvoir, Raymond Quesneau.

1944. Max Jacob dies in a German prison. 25th August–Liberation of Paris. Picasso joins the French Communist Party.

1945. Exhibitions in London, with Matisse, and in Brussels.

1946. Spends almost the whole year on the Côte d'Azure with Françoise Gilot, his new companion.

1947. Birth of his son Claude. Begins to work in ceramics at the Madoura factory at Vallauris.

1948. Attends the World Peace Congress in Poland. In October moves to Vallauris.

1949. Birth of his daughter Paloma.

1950. Attends the World Peace Congress in England.

1952. Paints two large compositions, *Peace* and *War*, in a chapel in Vallauris.

1953. Retrospective exhibitions in Lyons, Rome and Milan. Separation from Françoise Gilot.

1954. Meets Jacqueline Roque. Paints the fifteen variations on Delacroix's *Les Femmes d'Alger*. Retrospective exhibition in São Paolo.

1955. Death of Olga Koklova. Marries Jacqueline Roque. Moves to the villa La Californie, near Cannes.

1957. Paints the variations on Velasquez's *Las Meninas*.

1958. Paints the great mural for the UNESCO building in Paris. Buys the Château de Vauvenargues, near Aix-en-Provence.

1960. Big retrospective exhibition in London.

1961. Paints the variations on Manet's *Déjeuner sur l'Herbe*.

1964. Big retrospective exhibitions in Montreal, Toronto, Tokyo, Kyoto and Nagoya.

1966. Exhibition *Hommage à Picasso* organised to celebrate his eightieth birthday, promoted officially by the French Government and the City of Paris.

## Exhibitions and catalogues

1901. Galerie Ambroise Vollard, Paris.
1913. Moderne Galerie Thannhauser, Munich.
1918. Drawings, Galerie Paul Rosenberg, Paris.
1920. Galerie Paul Rosenberg, Paris.
1921. Leicester Gallery, London.
1922. Moderne Galerie Thannhauser, Munich.
1924. Galerie Paul Rosenberg, Paris.
1926. Galerie Paul Rosenberg, Paris.
1927. Drawings, Galerie Alfred Flechteim, Berlin.
1928. Drawings, Wildenstein Gallery, New York.
1930. Arts Club, Chicago.
1932. Galerie Georges Petit, Paris; Kunsthaus, Zürich.
1936. Sculpture, Galerie Cahiers d'Art, Paris.
1939–40. Museum of Modern Art, New York; Art Institute, Chicago.
1944. Salon d'Automne, Paris.
1949. Maison de la Pensée Française, Paris; Drawings, Art Museum, Princeton; Drawings and gouaches, Institute of Contemporary Art, London.
1953. Musée des Beaux-Arts, Lyons; Galleria Nazionale d'Arte Moderna, Rome; Palazzo Reale, Milan.
1954. *El Quatre Gats,* ed. R. Benet and R. Llates, Barcelona; *L'oeuvre gravé de Picasso,* Musée Rath, Geneva; Drawings 1903–7, Galerie Berggruen, Paris; Maison de la Pensée Française, Paris; Museo de Arte Moderno, San Paolo; *Das graphische Werk Picassos,* Kunsthaus, Zürich.
1955. *Picasso,* ed. M. Jardot, Musée des Arts Décoratifs, Paris; Haus der Kunst, Munich.
1956. Rheinisches Museum, Cologne; Kunsthalle, Hamburg; Drawings, Galerie Berggruen, Paris; *Picasso: 50 Years of his Graphic Art,* Arts Council of Great Britain, London.
1957. *Picasso: 75th Anniversary Exhibition,* ed. A. H. Barr, Jr., The Museum of Modern Art, The Art Institute, Chicago; Drawings, gouaches, watercolours, Musée Reattu, Arles; *Picasso: Peintures 1955–6,* Galerie Louise Leiris, Paris.
1958. Museum of Art, Philadelphia.
1959. *Picasso,* ed. D. Cooper, Musée Cantini, Marseilles; *Picasso: Les Menines,* Galerie Louis Leiris, Paris.
1960. *Picasso.* Retrospective exhibition. Tate Gallery, London; *Picasso: Dessins 1959–60* and *45 gravures sur linoleum,* Galerie Louise Leiris, Paris.
1961. University of California Art Gallery, Los Angeles; Drawings, gouaches, watercolours, Sala Gaspar, Barcelona.
1962. *Picasso, an American Tribute,* New York; Galerie Louise Leiris, Paris.
1963. Galerie Rosengart, Lucerne.
1964. Musée des Beaux-Arts, Montreal; *Picasso and Man,* J. S. Boggs Art Gallery, Toronto; Tokyo, Kyoto, Nagoya.
1965. *Picasso et le Théâtre,* Musée des Augustins, Toulouse; Drawings, Kunstverein, Frankfurt.
1966. Pavillon Helena Rubinstein, Tel Aviv.
1966–7. *Hommage à Pablo Picasso* (280 paintings, 200 drawings, 180 sculptures, 115 ceramic works), Grand Palais and Petit Palais, Paris.

26. Picasso at the Salon de Mai with his sculpture *Goat*

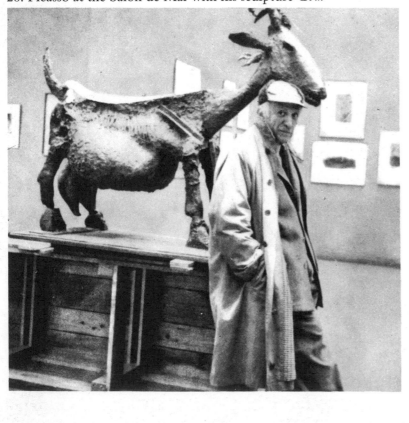

27. Gouache study in a note-book for *Bull-fight*, 2nd March, 1959

94

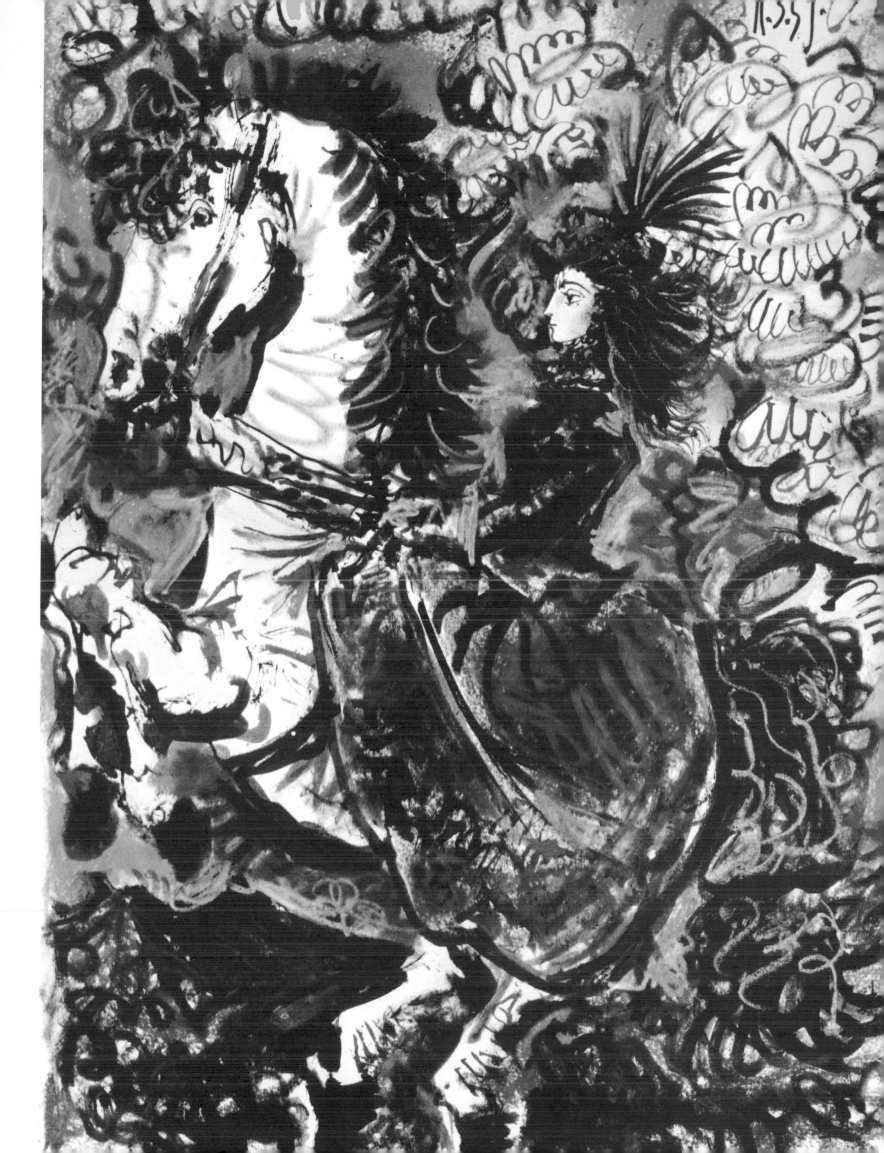

# Bibliography

G. APOLLINAIRE, *Les jeunes: Picasso peintre*, *La Plume*, 15th May, 1905; A. SALMON, *La jeune peinture française*, Paris, 1912; G. STEIN, *Camera Work* 29–30, New York, 1912; G. APOLLINAIRE, Les peintres cubistes, Paris, 1913; U. BOCCIONI, *Che cosa ci divide dal cubismo, Pittura, scultura futuriste*, Milan, 1914; M. RAPHAËL, *Von Manet zu Picasso*, Munich, 1919; D. H. KAHNWEILER, *Der Weg zum Kubismus*, Munich, 1920; M. RAYNAL, *Picasso*, Munich, 1921; J. COCTEAU, *Picasso*, Paris, 1923; W. GEORGE, *Picasso*, Rome, 1924; P. REVERDY, *Pablo Picasso*, Paris, 1924; J. COCTEAU, *Le rappel à l'ordre*, Paris, 1926; C. EINSTEIN, *Die Kunst des 20. Jahrhunderts*, Berlin, 1926; W. GEORGE, *Picasso, dessins*, 1926; *Cahiers d'Art* I, Paris, 1926; J. CASSOU, *Derniers dessins de Picasso*, *Cahiers d'Art*, Paris, 1927; M. JACOB, *Souvenirs sur Picasso*, *Cahiers d'Art*, 1927; O. SCHURER, *Pablo Picasso*, Leipzig, 1927; A. BRETON, *Le surréalisme et la peinture*, Paris, 1928; A. LEVEL, *Picasso*, Paris, 1928; W. UHDE, *Picasso et la tradition française*, Paris, 1928; L. ARAGON, *La peinture au défi*, Paris, 1930; M. DALE, *Picasso*, New York, 1930; E. D'ORS, *Pablo Picasso*, Paris, 1930; H. MAHAUT, *Picasso*, Paris, 1930; *Documents* 2, 3, Paris, 1930; T. TZARA, *Le papier collé ou le proverbe en peinture*, *Cahiers d'Art* 2, Paris, 1931; C. ZERVOS, *Pablo Picasso*, Milan, 1932; *Cahiers d'Art* 3–5, Paris, 1932; A. BRETON, *Picasso dans son élément*, *Minotaure* I, Paris, 1933; F. OLIVIER, *Picasso et ses amis*, Paris, 1933; M. RAPHAËL, *Proudhon, Marx, Picasso*, Paris, 1933; B. WEILL, *Pan! . . . dans l'oeil*, Paris, 1933; G. STEIN, *Autobiographie d'Alice B. Toklas*, Paris, 1934; *Cahiers d'Art* 7–10, Paris, 1935; J. GONZALES, *Picasso sculpteur*, *Cahiers d'Art* 6–7, Paris, 1936; *Gaceta de Arte* 37, Tenerife, 1936; A. BERTRAM, *Pablo Picasso*, New York, 1937; J. SABARTÈS, *Picasso*, Milan, 1937; *Cahiers d'Art* 4–5, Paris, 1937; G. STEIN, *Picasso*, Paris, 1938; *Cahiers d'Art* 3–10, Paris, 1938; P. ELUARD, *Je parle de ce qui est bien, Donner à voir*, Paris, 1939; R. MELVILLE, *Picasso, Master of the Phantom*, London, 1939; *London Bulletin* 15–16, London, 1939; J. CASSOU, *Picasso*, Paris, 1940; L. DANZ, *Personal revolution and Picasso*, New York, 1941; J. J. SWEENEY, *Picasso and Iberian sculpture*, *Art Bulletin* 3, New York, 1941; *Cahiers d'Art* I, Paris, 1941–4; J. MERLI, *Picasso, el artista y la obra de nuestro tiempo*, Buenos Aires, 1942; A. SOFFICI, *Ricordi di vita artistica e letteraria*, Florence, 1942; C. CARRÀ, E. PRAMPOLINI, G. SEVERINI, A. SOFFICI, *Cinquanta disegni di P. Picasso*, Novara, 1943; R. DESNOS, *Picasso: seize peintures, 1939–43*, Paris, 1943; E. PRAMPOLINI, *Picasso scultore*, Rome, 1943; P. ELUARD, *A Pablo Picasso*, Geneva, 1944; R. GOMEZ DE LA SERNA, *Completa y veridica historia de Picasso y el cubismo*, Torino, 1945; S. SOLMI, *Disegni di Picasso*, Milan, 1945; A. H. BARR, *Picasso, Fifty Years of his Art*, New York, 1946; A. CIRICI-PELLICIER, *Picasso antes de Picasso*, Barcelona, 1946; H. and S. JANIS, *Picasso, The Recent Years, 1939–46*, New York, 1946; W. S. LIEBERMAN, *Picasso and the Ballet*, New York, 1946; J. SABARTÈS, *Portraits et Souvenirs*, Paris, 1946 (English translation: *An Intimate Portrait*, New York, 1948); C. BRANDI, *Carmine della pittura* (with an essay on Picasso), Florence, 1947; W. ERBEN, *Picasso und die Schwermut*, Heidelberg, 1947; J. LARREA, *Pablo Picasso, Guernica*, New York, 1947; *Artès* 3–4, Anversa, 1947–8; J. SABARTÈS and P. ELUARD, *Picasso à Antibes*, Paris, 1948; T. TZARA, *Pablo Picasso et les Chemins de la connaissance*, Geneva, 1948; *Carnet de dessins de Picasso (1940–42)*, Paris, 1948; *Cahiers d'Art* I, Paris, 1948; *Verve* V, 19–20, Paris, 1948; *Ver y estimar* I, 2, Buenos Aires, 1948; D. H. KAHNWEILER, *Les sculptures de Picasso*, Paris, 1949; J. LASSAIGNE, *Picasso*, Paris, 1949; C. ZERVOS, *Dessins de Picasso, 1892–1948*, Paris, 1949; J. BOURET, *Picasso: dessins*, Paris, 1950; A. VERDET, *L'homme au mouton de Pablo Picasso*, Paris, 1950; P. FRANCASTEL, *Peinture et Société*, Lyons, 1951; M. GIEURE, *Initiation à l'oeuvre de Picasso*, Paris, 1951; *Verve* VII, 25–26, Paris, 1951; P. ELUARD, *Picasso, Dessins*, Paris, 1952; G. SCHMIDT, *Pablo Picasso*, Basel, 1952; A. VERDET, *Faunes et nymphes de Pablo Picasso*, Geneva, 1952; A. VERDET, *La Chèvre*, Paris, 1952; *Le Point* XLII, Souillac, October, 1952; G. C. ARGAN, *Sculture di Picasso*, Venice, 1953; G. C. ARGAN, *Moralismo di Picasso*, *Società*, Rome, September, 1953; C. BRANDI, *L'ultimo Picasso*, *Nuovi Argomenti*, Rome, November, 1953; M. RAYNAL, *Picasso*, Geneva/New York, 1953; *Commentari* IV, 3, Rome, 1953; *La Biennale di Venezia* 13–14 Venice, 1953; *Realismo*, Rome, March–April 1953; F. RUSSOLI, *Pablo Picasso*, Milan, 1954; *Du* 7, Zürich, July, 1954; *Verve* VIII, 29–30 Paris, 1954; (W. BOECK, preface by J. SABARTÈS), *Picasso*, London/New York, 1955; F. ELGAR and R. MAILLARD, *Picasso*, London/Paris, 1955; VERCORS, *Picasso, oeuvres des Musées de Leningrad et de Moscou*, Paris, 1955; *Kunstwerk* IX, 3, 1955; A. SALMON, *Souvenirs sans fin*, Paris, 1955–6; J. CAMON AZNAR, *Picasso y el cubismo*, Barcelona, 1956; P. DESCARGUES, *Picasso, témoin du XXe siècle*, Paris, 1956; R. PENROSE, *Portrait of Picasso*, New York, 1957; J. RICHARDSON, *Picasso's Ateliers and other recent works*, *The Burlington Magazine*, London, June, 1957; A. VALLENTIN, *Picasso*, Paris, 1957; L. C. BREUNIG, *Studies on Picasso, 1902–5*, *College Art Journal*, 1958; D. COOPER, *Picasso, Carnet Catalan*, Paris, 1958; D. D. DUNCAN, *The Private World of Pablo Picasso*, New York, 1958; J. GOLDING, *The Demoiselles d'Avignon*, *The Burlington Magazine*, London, May 1958; R. PENROSE, *Picasso: His Life and Work*, London, 1958; J. SABARTÈS, *Picasso, Les Menines et la vie*, Paris, 1958; G. SALLES, *Picasso, Mes dessins d'Antibes*, Paris, 1958; J. TARDIEU, *L'espace et la flûte, variations sur douze dessins de Picasso*, Paris, 1958; G. BOUDAILLE, *Pablo Picasso, carnet de la Californie*, Paris, 1959; L.-G. BUCHHEIM, *Picasso: A Pictorial Biography*, New York, 1959; J. GOLDING, *Cubism*, London, 1959; M. JARDOT, *Picasso, Dessins*, Paris, 1959; J. PREVERT, *Portraits de Picasso*, Milan, 1959; J. RUNNQUIST, *Minotauros 1900–37*, Stockholm, 1959; ARTS COUNCIL OF GREAT BRITAIN, *Catalogue to the retrospective exhibition at the Tate Gallery*, London, 1960; P. DE CHAMPRIS, *Picasso, ombre et soleil*, Paris, 1960; G. DIEHL, *Picasso*, Paris, 1960; DOR DE LA SOUCHERE, *Picasso à Antibes*, Paris, 1960; J. C. LAMBERT, *Picasso, dessins de tauromachie*, 1917–60, Paris, 1960; H. PARMELIN, *Picasso sur la place*, Paris, 1960; J. PADRTA, *Picasso: The Early Years*, London, 1960; *Papeles de son Armadans* V, 49, Valencia, 1960; R. ROSENBLUM, *Cubism and 20th-Century Art*, New York/London, 1960; L. M. DOMINGUIN and G. BOUDAILLE, *Toros y Toreros*, Paris, 1961;

D. D. DUNCAN, *Picasso's Picassos*, Lausanne/New York/London, 1961; R. PENROSE, *Sculptures de Picasso*, Paris, 1961; L. PREJGER, *Picasso découpe le fer*, *L'Oeil*, October, 1961; J. SABARTÈS, *A los toros avec Picasso*, Monte Carlo, 1961; *La Nouvelle Critique* 30, Paris, November 1961; R. ARNHEIM, *Picasso's Guernica. The Genesis of a Painting*, Los Angeles, 1962; A. BLUNT and P. POOL, *Picasso, The Formative Years, a Study of his Sources*, London/Connecticut, 1962; D. COOPER, *Picasso, Les Déjeuners*, Paris, 1962; J. PADRTA, *Picasso sconosciuto*, Rome, 1962; D. H. KAHNWEILER, *Confessions esthétiques*, Paris, 1963; G. BOUDAILLE, *Picasso, première époque 1881–1906*, Paris, 1964; BRASSAI, *Conversations avec Picasso*, Paris, 1964; P. DAIX, *Picasso*, Paris, 1964; F. GILOT and C. LAKE, *Life with Picasso*, London, 1964; H. JAFFE, *Picasso*, New York, 1964; H. PARMELIN, *Les Dames de Mougins*, Paris, 1964; J. RICHARDSON, *Picasso, acquarelles et gouaches*, Paris, 1964; S. TAKASHINA, *Picasso*, Tokyo, 1964; J. BERGER, *Success and Failure of Picasso*, London, 1965; H. KAY, *Picasso, le monde des enfants*, Grenoble, 1965; H. PARMELIN, *Le peintre et son modèle*, Paris, 1965; E. QUINN and R. PENROSE, *Picasso à l'oeuvre*, Paris, 1965; P. DAIX and G. BOUDAILLE, *Picasso 1900–6*, Neuchâtel-Paris, 1966; M. LEIRIS, *Brisées*, Paris, 1966; H. PARMELIN, *Notre-Dame-de-Vie*, Paris, 1966; C. ZERVOS, *Picasso: catalogue général illustré* (Catalogue of Works, in course of publication since 1932): *1895–1906*, 2nd ed. 1957; *1906–12*, 1942; *1912–17*, 1942; *1917–19*, 1949; *1920–22*, 1951; *1923–5*, 1952; *Supplement to volumes I–V*, 1954; *1926–32*, 1955; *1932–7*, 1957; *1937–9*, 1958; *1939–40*, 1959; *1940–41*, 1960; *1942–3*, 1961; *1943–4*, 1962; *1944–6*, 1963; *1946–53*, 1965; *1953–5*, 1965; *1956–7*, 1966; J. LEYMARIE, R. ARNOULD, A. CACAN, *Hommage à Pablo Picasso*, Paris, 1966–7; M. DE MICHELI, *Picasso*, Florence, 1967.